760

THE YELLOW BOOK

COLOURWORKS

THE YELLOW BOOK

DALE RUSSELL

PHAIDON · OXFORD

A QUARTO BOOK

Published by
Phaidon Press Limited
Summertown Pavilion
Middle Way
Oxford OX2 7LG

ISBN 0 7148 2713 4
ISBN 0 7148 2716 9 (boxed set of five in series)

First published 1991
Copyright © 1991
Quarto Publishing plc

A CIP catalogue record for this
book is available from the
British Library

This book was designed and produced by
Quarto Publishing plc
The Old Brewery, 6 Blundell Street
London N7 9BH

SENIOR EDITOR Sally MacEachern
EDITOR Paula Borthwick
DESIGNERS Penny Dawes, David Kemp, Julia King
PICTURE MANAGER: Joanna Wiese
PICTURE RESEARCH ADMINISTRATION
Prue Reilly, Elizabeth Roberts
PHOTOGRAPHERS: Martin Norris, Phil Starling

ART DIRECTOR Moira Clinch

Manufactured in Hong Kong by Regent Publishing Services Ltd
Typeset by Bookworm Typesetting, Manchester
Printed in Singapore by Tien Wah Press (Pte) Ltd

DEDICATION
With great love, I would like to thank my husband Steve for patiently guiding me through
the days and nights overtaken by colour and my daughter Lucy Scarlett for remaining
happy while colour came first.

CONTENTS

THE COLOURS

Using Colourworks

To make the most of the *Colourworks* series it is worthwhile spending some time reading this and the next few pages. *Colourworks* is designed to stimulate a creative use of colour. The books do not dictate how colour should be applied, but offer advice on how it may be used effectively, giving examples to help generate new ideas. It is essential to remember that *Colourworks* uses the four-colour process and that none of the colours or effects use special brand name inks.

The reference system consists of five books that show 125 colours, with 400 type possibilities, 1,000 halftone options, and 1,500 combinations of colour. But even this vast selection should act only as a springboard; the permutations within the books are endless. Use the books as a starting point and experiment!

When choosing colours for graphic design it is almost impossible to predict the finished printed effect. In order to save valuable time spent researching, you can use the series' extensive range of colours to provide references for the shade with which you are working.

The four process colours

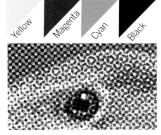

Yellow Magenta Cyan Black

▲ Enlarged detail showing how four process colours overlap to produce "realistic" colour.

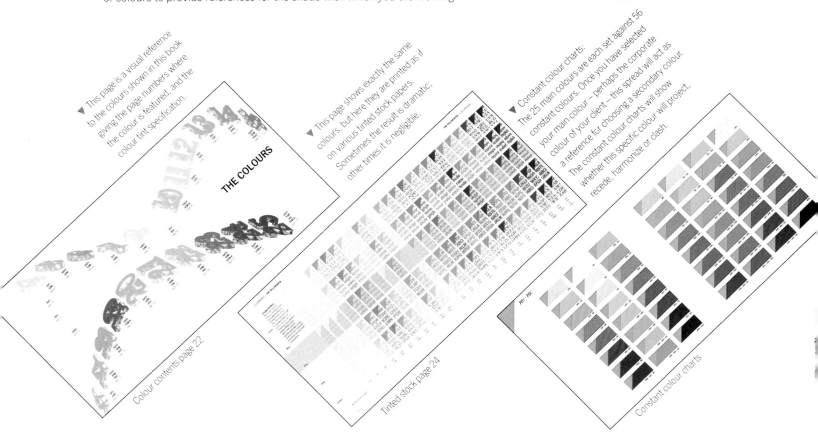

▼ This page is a visual reference to the colours shown in this book giving the page numbers where the colour is featured, and the colour tint specification.

THE COLOURS

Colour contents page 22

▼ This page shows exactly the same colours, but here they are printed as if on various tinted stock papers. Sometimes the result is dramatic; other times it is negligible.

Tinted stock page 24

▼ Constant colour charts: The 25 main colours are each set against 56 constant colours. Once you have selected your main colour – perhaps the corporate colour of your client – this spread will act as a reference for choosing a secondary colour. The constant colour charts will show whether this specific colour will project, recede, harmonize or clash.

Constant colour charts

The books are ideal for showing to clients who are not used to working with colour, so that they may see possible results. They will be particularly useful when working with a specific colour, perhaps dictated by a client's company logo, to see how this will combine with other colours. Equally, when working with several colours dictated by circumstances – and perhaps with combinations one is not happy using – you will find that the constant colour charts, colourways and applications will show a variety of interesting solutions. The numerous examples in *Colourworks* can act as a catalyst, enabling you to break out of a mental block – a common problem for designers who may feel that they are using a wide variety of colours but actually be working with a small, tight palette. Finally, when faced with a direct colour choice, you should use *Colourworks* in the same way you would use any other art aid – to help create the final image. The books are designed to administer a shot of adrenaline to the design process. They should be treated as a tool and used as a source of both information and inspiration.

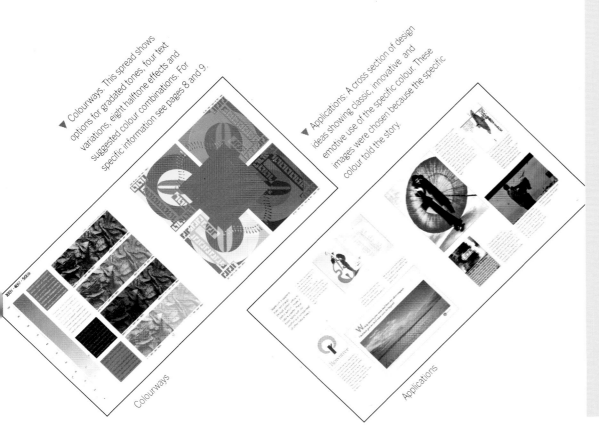

▼ Colourways: This spread shows options for gradated tones, four text variations, eight halftone effects and suggested colour combinations. For specific information see pages 8 and 9.

Colourways

▼ Applications: A cross section of design ideas showing classic, innovative and emotive use of the specific colour. These images were chosen because the specific colour told the story.

Applications

TERMINOLOGY USED IN COLOURWORKS

Main colour: one of the 25 colours featured in each book.

Colourway: The main colour plus two other colour combinations.

Constant colour: The main colour with 56 constant colours.

Y: yellow
M: magenta
C: cyan
Blk: black
H/T: halftone
F/T: flat-tone

TECHNICAL INFORMATION

When using *Colourworks* or any colour specification book, remember that paper stock, lamination and type of ink can change the effect of chosen colours. Coated papers, high-quality especially, tend to brighten colours as the ink rests on the surface and the chalk adds extra luminosity, while colours on uncoated paper are absorbed and made duller. Lamination has the effect of making the colour darker and richer.

Colourworks specification

Colour bar GRETAG
Screen 150L/IN
Film spec.: AGFA511P
Tolerance level: +2% – 2%
Col. density: C=1.6 – 1.7
M=1.4 – 1.5
Y=1.3 – 1.4
Blk=1.7 – 1.8
Ink: Proas
Paper: 130gsm matt coated art
Plate spec.: Polychrome
Dot gain: 10%
Printed on Heidelberg Speedmaster 102v
Printing sequence: Black/Cyan/Magenta/Yellow

On the next four pages you can see, in step-by-step form, exactly how to understand and use the colour reference system shown in *Colourworks* and how you can incorporate the ideas into your designs.

It is essential to remember that *Colourworks* uses the four-colour process – none of the effects uses the special brand name ink systems – usually described as "second colours".

1. GRADATED COLOUR

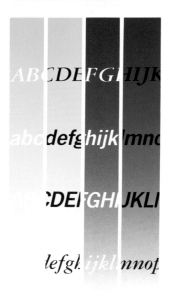

The colour scale shows the main colour fading from full strength to white. If you are using a gradated background, the scale clearly demonstrates at what point reversed-out-type would become illegible – with a dark colour you may be able to reverse out down to 20% strength, with a pastel only down to 80% or perhaps not at all, in which case the type should be produced in a dark colour.

The opposite would be true if the design incorporated dark type on a fading dark colour. Again, unless a very subtle result is required, the scale indicates at what point type would become illegible.

The other use of the fade gives the designer more colour options – perhaps you like the colour on page 102, but wish it was slightly paler. With the gradated shading you can visualize just how much paler it could be.

2. TYPE OPTIONS

The main colour with different type options: solid with white reversed out; type printing in the colour; black and the type reversed out as colour; solid with black type. These examples demonstrate the problems of size and tonal values of the type.

The type block is made up of two typefaces, a serif and sans serif, both set in two different sizes.

9pt New Baskerville

7pt New Baskerville

Ossidet sterio binignuis

gignuntisin stinuand. Flourida

trutent artsquati, quiateire

semi uitantque tueri; sol etiam

8½pt Univers 55 7pt Univers 55

Size

Using the four-colour process the designer obviously has no problems choosing any combination of tints when using large type, but how small can a specific colour type be before it starts to break up or registration becomes a problem? The type block shows when the chosen tints work successfully and more important *when they do not*.

9pt New Baskerville: 70% Yel demonstrates no problems.

gignuntisin stinuand. Flourida prat gereafiunt quaecumque

7pt New Baskerville 100%Y 70%M 30%C 50% Blk the serifs start to disappear.

Tonal values

Obviously, when dealing with middle ranges of colour, printing the type black or reversed out presents no legibility problems. But the critical decisions are where the chosen colours and shade of type are close. Will black type read on dark green? Will white type reverse out of pale pink? When marking up colour, it is always easier to play safe, but using the information in *Colourworks* you will be able to take more risks.

Ossidet sterio binignuis tultia, dolorat isogult it

Ossidet sterio binignuis tultia, dolorat isogult it

The problem is shown clearly above: using a pastel colour (top) it would be inadvisable to reverse-out type; with a middle shade (centre) the designer can either reverse out or print in a dark colour; while using a dark colour (bottom), printing type in black would be illegible (or very subtle).

3. HALFTONE OPTIONS

This section demonstrates some possibilities of adding colour to black and white halftones where the normal, "realistic" four-colour reproduction is not desired or when the originals are black and white prints. This section gives the designer 800 options using various percentages and combinations of the process colours.

100% main colour　　　　　**50% strength of main colour**

100% black H/T plus full strength of the main colour

100% black H/T plus 50% of the main colour

50% black H/T plus full strength of the main colour

50% black H/T plus 50% of the main colour

100% black H/T plus a *flat* tint of the main colour at full strength

100% black H/T plus a *flat* tint of the main colour at half strength

H/T using only the main colour at full strength

H/T using only the main colour at half strength

Moiré pattern

Some of the main colours in this book include percentages of black. If this film is combined with the black film from the halftone a moiré pattern can occur. To overcome this possibility the films for *Colourworks* have been prepared in two ways. When the main colour is made up of 3 colours or less, e.g. p70, the two black films have been specially angled. When the main colour is made up of four colours plus the extra black (p140 only) it is impossible to create an extra screen angle. In order to give the effect of the extra black, the repro house has strengthened the black H/T dot in the mid tones and highlights by the appropriate percentage. However, moiré pattern will occur on the flat tint section. Discuss this with your repro house if you want to use B/W halftones with these few colours.

4. COLOURWAYS

This page shows the main colour with other colours. It acts as a guide to help the designer choose effective colour for typography and imagery. Each colour is shown as four colourways; each colourway shows the main colour with two others.

The three colours in each colourway (corner) are in almost equal proportions. The effect would change dramatically if one colour was only a rule or small area. Use the colourways to find the appropriate range for your design and adapt it accordingly.

For information on using the central square and its use in commissioning photography or illustration see page 10.

The choice of colour has not been limited to the safe options. The easy neutrals cream, white and grey have been used, but so have more unusual combinations.

The colours show various effects; look at each corner, if necessary isolating areas.

▼ Colours are shown projecting forwards sometimes using the laws of optics which say that darker, cooler shades recede.

▲ These are classic colour combinations.

▲ Colours that are similar in shade.

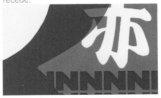

▲ Sometimes, due to the proportions, defying them.

abcdefghi

▲ Use these colours for background patterns, illustrations or typographic designs where the colour emphasis has to be equal.

abcdefgh

▲ These colours are not advisable if your design needs to highlight a message.

Analyse your design to see how dominant the typography, illustrations and embellishments need to be versus the background, then use the colourways to pick the appropriate colours or shades.

When selecting colours, it is very important to eliminate any other colour elements that might affect your choice. As has been demonstrated in the colour optics section (p.14), the character of a colour can be dramatically changed by other, adjacent colours.

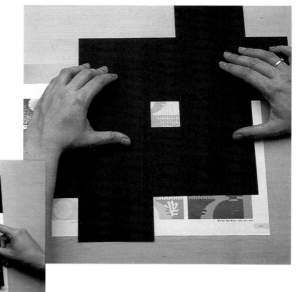

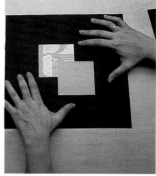

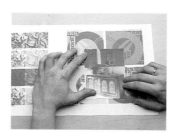

◀ ▲ The colourways have been designed in such a way that you can mask out the other colour options – isolating the area you want to work with or even small sections of each design.

▼ ▶ The colourways can also be used if you are selecting the colour of typography to match/enhance a photograph or illustration; again masking out the other colourways will help. A print of the photograph or illustration can be positioned in the central area, and the mask moved around.

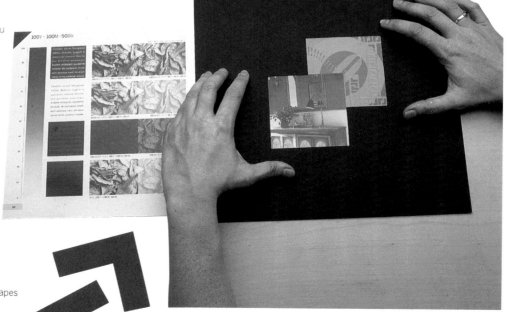

Useful mask shapes

The design shown on this page was created to demonstrate the practical use of *Colourworks*. It combines many halftone effects and colour combinations.

The options illustrated are drawn from *The Yellow Book*. For more suggestions and further inspiration, refer to the other books in the series.

▶ Using elements from *The Yellow Book* pages 128-29, 130-31.

◀ Using elements from *The Yellow Book* pages 40-41, 42-43.

Yellow introduction

"Any of a group of colours that vary in saturation but have the same hue. They lie in the approximate wavelength range 585-575 nanometres. Yellow is the complementary colour of blue and with cyan and magenta forms a set of primary colours."

Collins English Dictionary, Publishers: William Collins Sons and Co. Ltd., London & Glasgow; Second Edition 1986

"Of the colour of buttercups and ripe lemons, or of a colour approaching this."

Oxford American Dictionary, Publishers Oxford University Press, New York, U.S.A. 1980

Colour is not tangible; it is as fluid as a musical note. Although it may be described, the verbal or written words often bear no relation to its actual form. Colour has to be seen in context, for a single shade used in conjunction with another colour can take on a whole new character. Searching for a particular shade can be very confusing – somewhat like humming a tune and searching for a forgotten note.

No matter how much theory exists, it is the eye of the designer or artist that is responsible for using colour creatively. The fact that colour can be rationalized and then break its own rules with complete irrationality is what makes it so fascinating.

This book is about process colour. By the very nature of the process system, colours are not blended, as with pigments, but shades are selected visually by percentage. Unlike pigment colours, process colours can be mixed without losing any of their chromas. The process primary colours are magenta, yellow, and cyan, with black to create density and contrast, allowing dot saturation to establish values of lightness and darkness. The pigment primaries are red, blue and yellow.

The concept of process colour is not really new. The German poet and scientist Goethe (1749-1832) looked at effects of light and darkness on pigment colour in a way that strongly relates to modern interpretation of process colour. In complete contrast, a practical approach was taken by the 20th-century German painter Hickethier, who created a precise notation system based on cyan, magenta, and yellow for printing. Between these two extremes lies the concept of the process colour system.

The colours used in these books had to be systematically chosen to prevent *Colourworks* from dating or the colours from being a purely personal choice. It was important to rely on theory and I finally selected over a thousand colours for the five books that make up this series. This meant working with literally thousands of colours, and yet in spite of this comprehensive palette, there would still be a precise shade that would remain elusive.

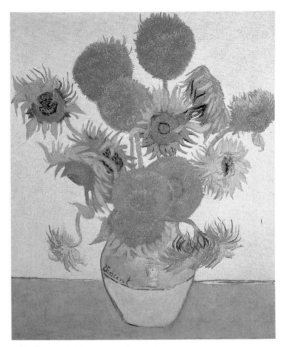

*Sunflowers by Vincent van Gogh (1853-90). Yellow is the atmosphere,
the imagery and, through application, the texture.*

My next major task was to select each image from advertising agencies, design consultancies,
illustrators and actually "off the walls". Every piece of printed matter, label, carrier bag or
magazine was a potential gold mine of material for the books. Many images had to be excluded,
even though they had superb colouration, because they did not tell a story with one
predominant colour.

Colourworks examples had to have immediate impact, with one colour telling the story–whether in
harmony with others, through shock tactics, providing a backdrop, creating a period setting,
making instant impact for the recognition of the image content, or simply combining superb use
of colour with design.

Colour combinations are infinite, and every day wonderful examples of colour and design are being
created. Having drawn from just some of these images, I hope that the *Colourworks* series will
become a reference to inspire, confirm and enjoy.

Dale Russell

Optical illusion, proportion and texture

The painter Wassily Kandinsky described yellow as a lively colour which upsets when looked at for a long time and then becomes shrill.

Yellow is the most visible of colours. With its secondaries it attracts attention, and achieves high visibility when teamed with black and white. Lime green and orange can create a fluorescent effect with good visibility.

A bluish-purple is the complementary colour of yellow, and these two colours can be used together with great effect. Pink subdues yellow; green is compatible with yellow and adds vitality to it. Next to it orange becomes more brilliant; next to violet it becomes harsh and strong. Red gives yellow dynamism. Lime green can appear crude or common in some contexts, but is currently extremely popular in contemporary design and clothing. It also has good visibility for graphics and packaging.

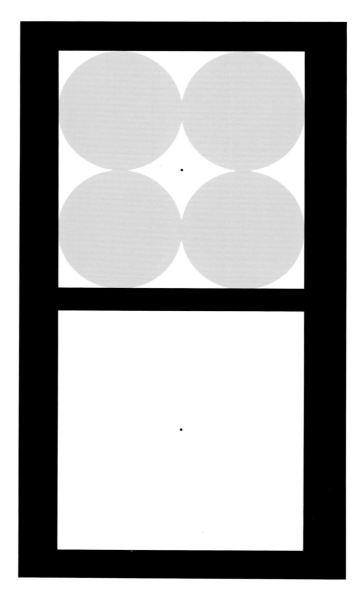

▲ If you stare at the centre of the yellow diagram for 40 seconds and then at the black dot on the white space, the after image created on the white area has violet-blue circles with yellow diamond shapes between. This double interaction of complementary colours was first recognized by Josef Albers and is still of interest to researchers.

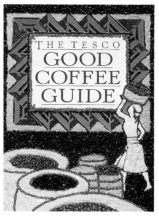

▲ The chrome border and the red strip create a sensation of movement which is reinforced by the increase in size of the photographic images.

▲ The page is created with texture and pattern in colours from the same family. The coffee shades, contrasting with yellows and russet have a strongly tactile effect.

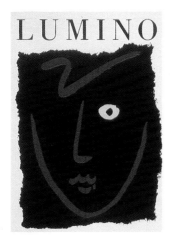

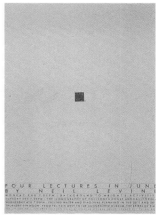

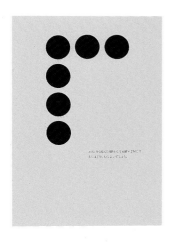

▲ The stark contrast of black on yellow creates extreme visibility. The use of yellow intensifies the black, which in turn brings clarity to the yellow.

▲ The laws of light and colour are applied with great effect here. By using black for the first application the designer has allowed the magenta to project, but the greatest impact is reserved for the yellow eye, which appears to shine.

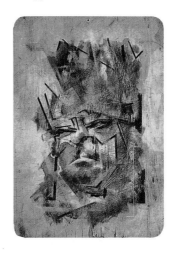

▲ The textured application of ochred tones in varying shades creates an image with depth and contour. This use of hues and intensities, in conjunction with black lines, subtly forms a portrait.

▲▲ This true optical illusion is created by the brightly contrasting yellow on blue. The yellow triangle is 'cut out' of the yellow square, revealing a blue triangle – or is it a blue triangle 'pasted over' the yellow square?

▲ The small red square appears to recede into the yellow background, and yet it acts as a perfect contrast to give visibility to the same shade of red typography.

Psychology

All yellows conjure up nature, from the rich
browns of the earth to the golden life-giving
rays of the sun and the verdant greens of
lush foliage. Hues of yellow create much of
the palette of spring, summer and autumn.
If yellow represents the sun, flowers and
fruits, then green is the essence of growth.

The nature of yellow can be completely altered
by changing intensities and tones. Whereas
the ripe, rich orange of a setting sun
dramatically enriches the skyline, the henna
tones of the earth can be rich and tactile. A
soft, pale yellow is supposed to encourage
concentration, and schoolrooms are often
painted this colour. Chrome yellow exudes a
feeling of warmth with almost the same
intensity as red, whereas nothing can be
more garish than acid yellow or lime green.

Although yellow represents light and energy, it is
also associated with sickness, for example,
"bile green" and "jaundice yellow". At sea,
quarantine is indicated with a yellow flag.

Nature has created a danger warning system
based on the combination of yellow and
black. Some species of bee, wasp, snake
and frog have black and yellow stripes to
warn that they are poisonous. In many parts
of the world, humans have adopted this
warning signal by printing black on yellow
signs for areas where there is poison, toxic
fumes or radiation.

Traffic light systems use green to represent "go",
while amber becomes the warning sign –
"caution". These colours can produce
subliminal reactions if the design refers to
this system through colour and pattern.

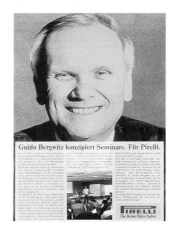

▲ By ingeniously relying on
the direct psychological
association of yellow and
lemons it was possible for the
designer to adopt a minimalist
approach to advertising the
product. This has been taken
one step further by the
confident use of black for the
teasing question which
assumes that the answer will
be "lemon juice".

▲ It is psychologically
disturbing to see a bright
yellow face. The image
has immediate impact and
leaves a lasting impression.
The yellow tint directly
complements the chrome
and red logo, giving unity to
the entire advertisement.

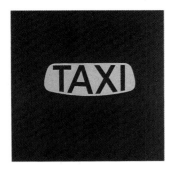

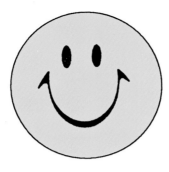

▲ This immediately recognizable logo has been adopted by many groups and cults from the city of Glasgow to the Acid House cult. The canary yellow with the smiling black graphics is also strongly attractive to young children, representing as it does the sun and happiness.

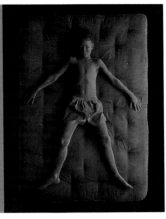

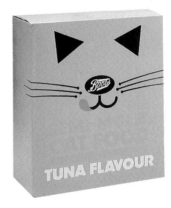

▲ One immediately becomes aware of the agonies an asthmatic must go through when faced with the terrors of dust. The claustrophobic atmosphere is conveyed by the grey dust colouration of the child and the bed. Although salvation is offered in the text of the brighter facing page, the particular shade of leaf green chosen is still tonally sympathetic with the grey.

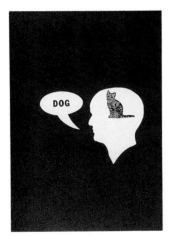

▲▲ In this simple design, direct colour association has been used to reiterate the sign's message. In many countries amber and black will conjure up the image of a cab, although in this case the black background refers specifically to the British hackney cab.

▲ The use of colour manipulates the reaction: the first thing we see is the colour – ginger, appropriate for a cat. Next we see the black type on white and read "dog". Result – utter confusion!

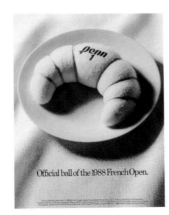

▲ Although the colour and texture are immediately recognizable as that of a tennis ball, the shape is that of a croissant. Association through colour and form allows the image to evoke both tennis and France.

▲ Colour and graphics combine to transform a plain grey box into a satisfied cat. The yellow type completes the illusion, harmonizing with the coral tongue and bringing warmth to the entire package.

Marketing

The broad spectrum of yellow encompasses different hues which are popular with all ages and sexes; from the browns, that have a limited appeal when used alone, to unconventional shades such as lime and orange which are popular for both direct mail and contemporary graphics.

When used for packaging, yellow blends with orange, brown and green for various natural and country-style looks. However, yellow with a green hue is a poor choice for food packaging, because it makes one think of mould and rotting food; the same can be said of certain shades of green.

Yellow and green create the atmosphere of sun, forest, sand and palm trees, enticing the reader to travel. Cream and buttercup yellow evoke dairy products, while the natural ochre shades suggest a healthful diet. Lime, orange and lemon are the citrus colours, immediately associated with these fruits.

Yellow makes objects look larger and appear to advance toward the consumer and therefore has great impact on the shelf. Combining yellow with colours such as red, royal blue or black creates a dynamic effect. Pure orange is good for packaging where a dramatic effect is desired.

▲ The evolution of the orange blossom is portrayed through the link between pollination, honey and the bee, using a traditional botanical illustration. A combination of the tones within the illustration reflect the colour of the honey. A pure and natural image is created for the buyer who is both selective and health conscious.

▲ Bright orange teamed with teal blue echoes the statement "basic and exciting": the intensity of the orange is given stability by the muted blue. This is for the young and astute, individualistic market.

▲ In this packaging the design concept is that of purity, health, tradition and ecology. The uncluttered approach implies a guarantee of good value. Shafts of golden light illuminate the cinnamon tones of the packaging, while the use of sienna against pure white for the logo reinforces the message of natural food.

▲ The use of different hues and intensities of brown gives this series of academic books visual continuity. All the shades of brown provide perfect backgrounds for the discreet graphics and, placed together, they form a sophisticated display.

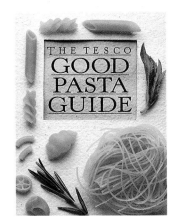

▲ To reinforce the natural qualities of pasta the book jacket uses colours drawn from nature. This theme is reinforced by the textured, undyed paper. The golden yellow of the pasta glows against the pale background and is brought to life by the green herbs.

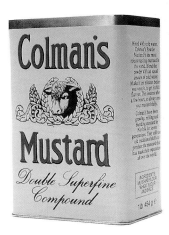

▲ A distinctive application of bold carmine red typography on a vibrant chrome yellow background, and the delicate use of black for the graphics and calligraphy, form a classic label. The colours chosen are both memorable and clearly visible, while retaining an aura of tradition and high standards that would satisfy the most discerning of shoppers.

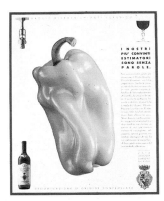

▲▲ The orange typography clashes with the red logo and stands out boldly against the blue background. This is dynamic marketing accurately aimed at a specialist sector.

▲ This readily evokes images of shopping for groceries in local markets on foreign trips. The ripe, sensuous yellow of the pepper and the glass of red wine, with its matching border, will appeal to the discerning shopper.

Culture and period

Throughout the Christian world, yellow is synonymous with Easter, which falls in spring in the northern hemisphere – a time of new life. Yellow was used in the backgrounds of religious paintings by early masters to represent the kingdom of sun and light. It is symbolic of a hidden truth and the glory of Christ's resurrection. Conversely, however, Judas was often depicted wearing a yellow coat.

In some eastern religions yellow is a sacred colour – Buddhist monks wear saffron robes, and in China the emperor is associated with yellow. However, in a totally different context, "yellow books" in China are pornographic ones – a usage similar to that of "blue" in the West. In Pakistan, yellow and black represent hell. Orange should be used with caution in the Republic of Ireland, where it has strong associations with the Protestant religion and the Orangemen.

In the United States, a yellow ribbon was traditionally worn by the women waiting for their men to come home from the cavalry during the late 19th century. The ribbon represented the yellow neckerchiefs worn by the soldiers. Conversely in 1876 American women wore yellow ribbons as a sign of their struggle for women's rights. In English-speaking countries, the expression "follow the yellow brick road" from the book and film *The Wizard of Oz* has overtones of a hopeful journey.

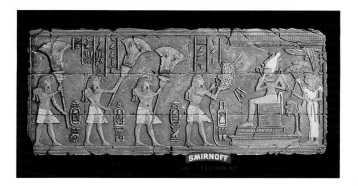

▲ Egyptian hieroglyphics are given authenticity by the colour palette of natural pigments used for wall painting in early Egypt. It is only a second glance that makes one aware of the anachronism.

▲ An educated, 20th-century awareness of the importance of conserving the natural environment is reflected in the creation of this book. The use of natural colours not only emphasizes a holistic approach to the materials but also complements the ecological message.

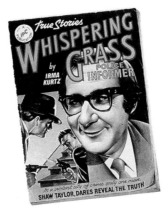

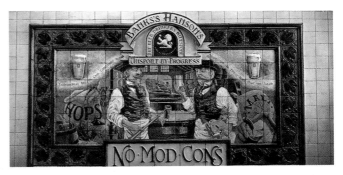

▲ ▲ The exotic flavour of this dust jacket is intensified by the overall use of yellow and orange tones, combined with green. Colour and graphics unite to bring a pre-historic culture to life.

▲ The 1940s image is retained in the updated graphics for the packaging of these French cigarettes. Traditionally Gauloises have always had a blue and white packet so the introduction of yellow is immediately noticeable. Even for those who have not seen the original packet, the yellow headlights have instant impact.

▲ The colour and graphics here are immediately evocative of the early 1950s. The use of mustard with black and minimal amounts of red dates the illustration.

▲ ▲ Everything in this image conspires to create a strong impression of the late Victorian period. Shades of orange, brown and black evoke an impression of age, asserting that this beer is the original product, unspoiled by time. This atmosphere is reinforced by applying the image to tiles.

▲ Femininity and desirability are romantically portrayed on this box for a floral toilet water which echoes the sepia tones of early 20th-century design. The seductive pink tones are cocooned by soft shades of brown, while the introduction of gold conveys the idea of excellence.

▲ Cadmium yellow, combined with magenta, red and turquoise, creates a discordant palette, punctuated by grey, black and blue. This daring use of colour is typical of that found in the experimental youth culture graphics of independent publications in the late 1980s.

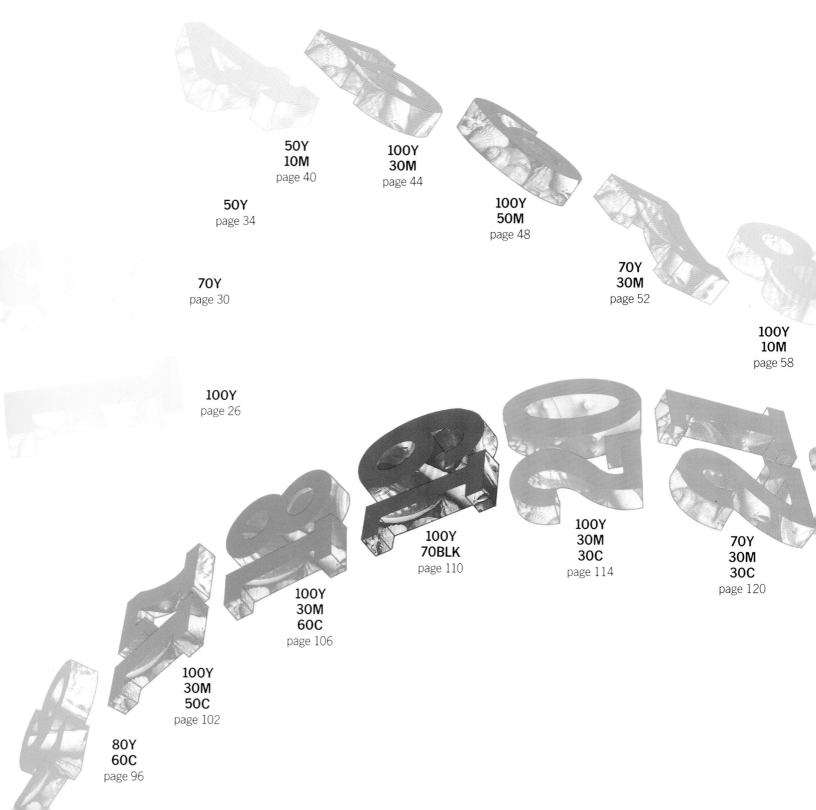

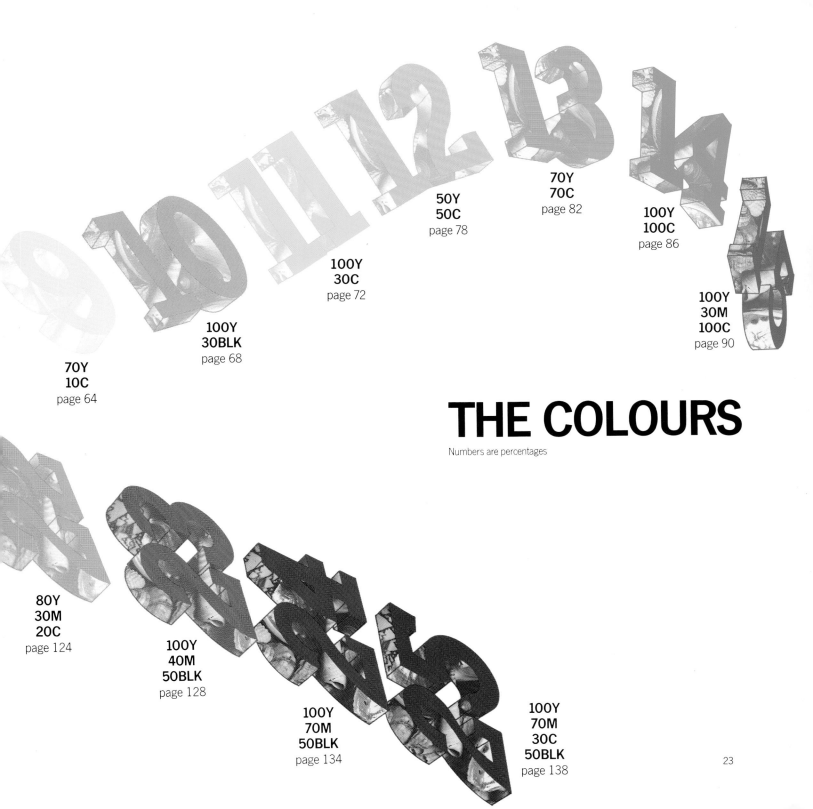

70Y
70C
page 82

50Y
50C
page 78

100Y
30C
page 72

100Y
100C
page 86

100Y
30M
100C
page 90

100Y
30BLK
page 68

70Y
10C
page 64

THE COLOURS

Numbers are percentages

80Y
30M
20C
page 124

100Y
40M
50BLK
page 128

100Y
70M
50BLK
page 134

100Y
70M
30C
50BLK
page 138

23

COLOURS ON TINTS

The 25 main colours are printed on background tints to simulate the effect of printing colour on printed stock. This chart can be used in a number of ways: as a guide to see how pale your chosen colour can go before it merges with the printed stock; to determine the aesthetic advantages of using a particular colour on a specific stock and to experiment with subtle patterns.

The corner flashes (triangles) show the main colour in its pure state, while the lettering shows the colour printed on the tint.

Green

Blue

Pink

Grey

Cream

| 100Y | 70Y | 50Y | 50Y 10M | 100Y 30M | 100Y 50M | 70Y 30M | 100Y 10M | 70Y 10C | 100Y 30BLK | 100Y 30C |

Numbers are percentages

50Y 50C	70Y 70C	100Y 100C	100Y 30M 100C	80Y 60C	100Y 30M 50C	100Y 30M 60C	100Y 70BLK	100Y 30M 30C	70Y 30M 30C	80Y 30M 20C	100Y 40M 50BLK	100Y 70M 50BLK	100Y 70M 30C 50BLK

20M

40Y

30M · 20C

40M · 10Y

60Y

40M · 30C

50M · 20Y

80Y

50M · 40C

70M · 40Y

100Y · 10M

60M · 50C

80M · 40Y

100Y · 20M

70M · 60C

90M · 50Y

100Y · 40M

80M · 70C

100M · 80Y

100Y · 20M · 10C

90M · 80C

100M · 80Y · 20C

100Y · 40M · 20C

100M · 100C

40C

20C • 50Y

60Y • 30M

10Blk

60C

40C • 100Y

70Y • 50M

30Blk

80C • 10M

50C • 80Y

70Y • 80M

50Blk • 10Y

100C • 30M

80C • 100Y • 10M

90Y • 70M • 10C

50Blk • 10M

90C • 40M

100C • 80Y • 10M

90Y • 70M • 30C

70Blk

100C • 50M • 10Y

100C • 100Y • 40M

90Y • 80M • 40C

70Blk • 30C

100C • 60M

100C • 100Y • 60M

100Y • 90M • 50C

80Blk

100C • 80M • 10Y

100C • 100Y • 80M

100Y • 100M • 80C

100Blk

100Y

NOTE: For technical information see page 6

100Blk H/T • H/T's: **100**Y — 100Blk H/T • H/T's: **50**Y

50Blk H/T • H/T's: **100**Y — 50Blk H/T • H/T's: **50**Y

100Blk H/T • F/T's: **100**Y — 100Blk H/T • F/T's: **50**Y

Ossidet sterio binignuis tultia, dolorat isogult it gignuntisin stinuand. Flourida prat gereafiunt quaecumque trutent artsquati, quiateire lurorist de corspore orum semi uitantque tueri; sol etiam caecat contra osidetsal utiquite

Ossidet sterio binignuis tultia, dolorat isogult it gignuntisin stinuand. Flourida prat gereafiunt quaecumque trutent artsquati, quiateire lurorist de corspore orum semi uitantque tueri; sol etiam caecat contra osidetsal utiquite

H/T's: **100**Y — H/T's: **50**Y

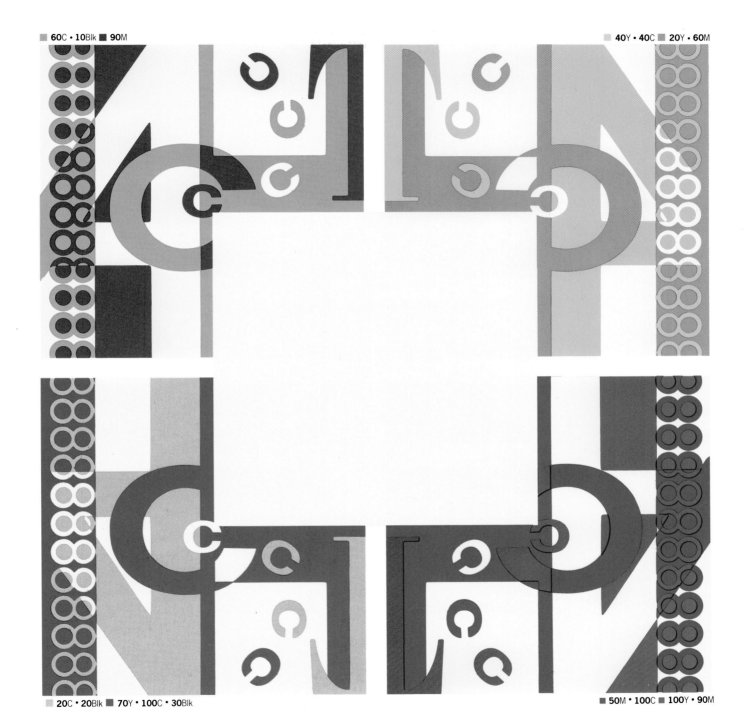

60C • 10Blk ■ 90M

40Y • 40C ■ 20Y • 60M

20C • 20Blk ■ 70Y • 100C • 30Blk

■ 50M • 100C ■ 100Y • 90M

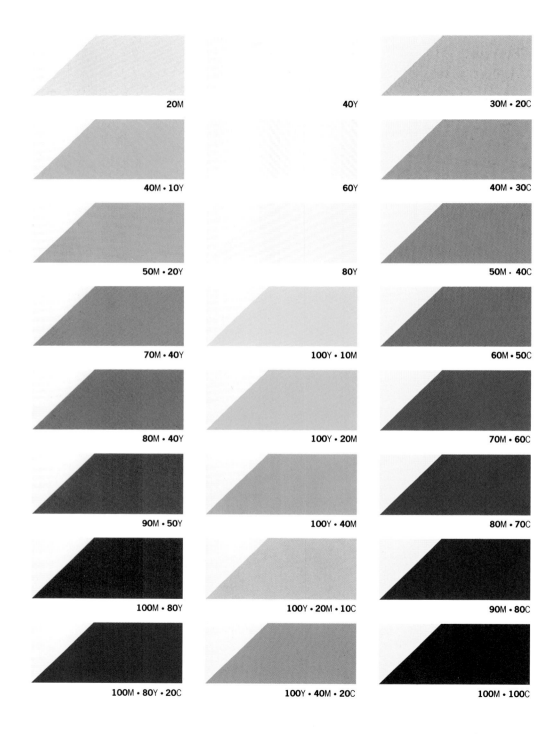

20M

40Y

30M · 20C

40M · 10Y

60Y

40M · 30C

50M · 20Y

80Y

50M · 40C

70M · 40Y

100Y · 10M

60M · 50C

80M · 40Y

100Y · 20M

70M · 60C

90M · 50Y

100Y · 40M

80M · 70C

100M · 80Y

100Y · 20M · 10C

90M · 80C

100M · 80Y · 20C

100Y · 40M · 20C

100M · 100C

40C

20C • 50Y

60Y • 30M

10Blk

60C

40C • 100Y

70Y • 50M

30Blk

80C • 10M

50C • 80Y

70Y • 80M

50Blk • 10Y

100C • 30M

80C • 100Y • 10M

90Y • 70M • 10C

50Blk • 10M

90C • 40M

100C • 80Y • 10M

90Y • 70M • 30C

70Blk

100C • 50M • 10Y

100C • 100Y • 40M

90Y • 80M • 40C

70Blk • 30C

100C • 60M

100C • 100Y • 60M

100Y • 90M • 50C

80Blk

100C • 80M • 10Y

100C • 100Y • 80M

100Y • 100M • 80C

100Blk

NOTE: For technical information see page 6

100Blk H/T • H/T's: **70**Y

100Blk H/T • H/T's: **35**Y

50Blk H/T • H/T's:**70**Y

50Blk H/T • H/T's: **35**Y

Ossidet sterio binignuis tultia, dolorat isogult it gignuntisin stinuand. Flourida prat gereafiunt quaecumque trutent artsquati, quiateire lurorist de corspore orum semi uitantque tueri; sol etiam caecat contra osidetsal utiquite

100Blk H/T • F/T's: **70**Y

100Blk H/T • F/T's: **35**Y

Ossidet sterio binignuis tultia, dolorat isogult it gignuntisin stinuand. Flourida prat gereafiunt quaecumque trutent artsquati, quiateire lurorist de corspore orum semi uitantque tueri; sol etiam caecat contra osidetsal utiquite

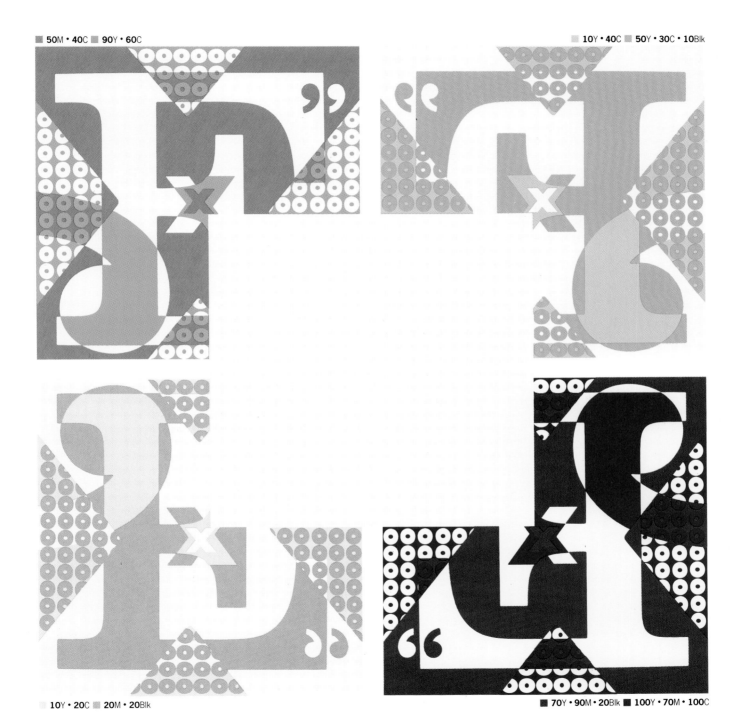

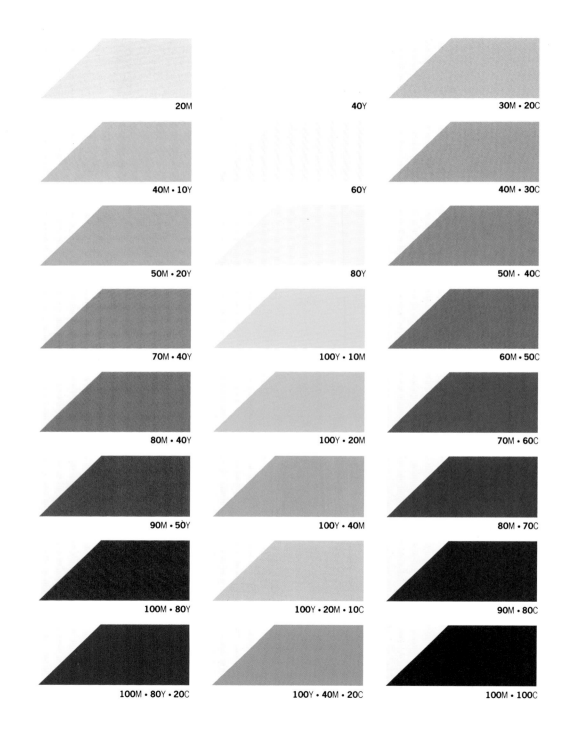

20M

40Y

30M・20C

40M・10Y

60Y

40M・30C

50M・20Y

80Y

50M・40C

70M・40Y

100Y・10M

60M・50C

80M・40Y

100Y・20M

70M・60C

90M・50Y

100Y・40M

80M・70C

100M・80Y

100Y・20M・10C

90M・80C

100M・80Y・20C

100Y・40M・20C

100M・100C

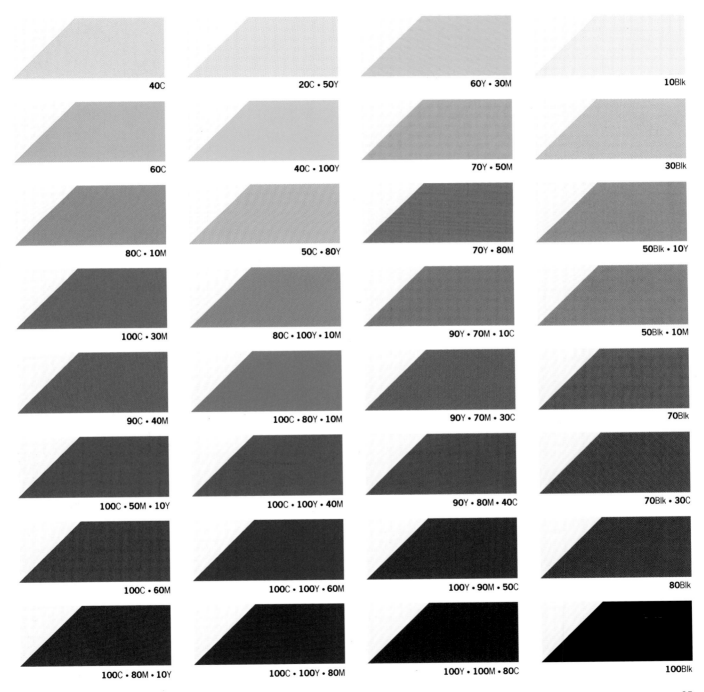

40C	20C • 50Y	60Y • 30M	10Blk
60C	40C • 100Y	70Y • 50M	30Blk
80C • 10M	50C • 80Y	70Y • 80M	50Blk • 10Y
100C • 30M	80C • 100Y • 10M	90Y • 70M • 10C	50Blk • 10M
90C • 40M	100C • 80Y • 10M	90Y • 70M • 30C	70Blk
100C • 50M • 10Y	100C • 100Y • 40M	90Y • 80M • 40C	70Blk • 30C
100C • 60M	100C • 100Y • 60M	100Y • 90M • 50C	80Blk
100C • 80M • 10Y	100C • 100Y • 80M	100Y • 100M • 80C	100Blk

NOTE: For technical information see page 6

100

90

80

70

60

50

40

30

20

10

0

100Blk H/T • H/T's: **50**Y 100Blk H/T • H/T's: **25**Y

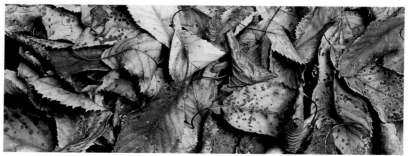

50Blk H/T • H/T's: **50**Y 50Blk H/T • H/T's: **25**Y

100Blk H/T • F/T's: **50**Y 100Blk H/T • F/T's: **25**Y

Ossidet sterio binignuis tultia, dolorat isogult it gignuntisin stinuand. Flourida prat gereafiunt quaecumque **trutent artsquati, quiateire lurorist de corspore orum** semi uitantque tueri; sol etiam caecat contra osidetsal utiquite

Ossidet sterio binignuis tultia, dolorat isogult it gignuntisin stinuand. Flourida prat gereafiunt quaecumque **trutent artsquati, quiateire lurorist de corspore orum** semi uitantque tueri; sol etiam caecat contra osidetsal utiquite

H/T's: **50**Y H/T's: **25**Y

■ 10Y • 60M • 100C ■ 40Y • 40C

■ 10Y • 20C • 10Blk ■ 20M • 10C

■ 60Y • 30M ■ 10Y • 30C

■ 10Y • 80M • 20C ■ 20C • 80Blk

A luminous yellow, a yellow of activity - fluorescent, positive, and electric. It attracts fellow pigment primaries – red and blue – but counters the process primaries, magenta and cyan.

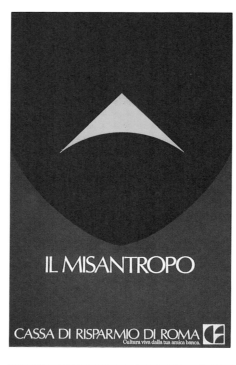

◀ This image is created by the use of simple graphics and a strong, unconventional colour palette. The three-dimensional effect is achieved in two ways: the application of colours in three layers, and the creation of an optical illusion by placing a complementary process yellow onto royal blue above a tonal shade of teal. The white type projects from the teal background.

▼ This anarchic approach to colour reflects the chaotic modernist graphics as well as the subject of the book. The disharmony of brash process yellow against soft peach and Wedgwood blue is bridged by the scattered touches of *café au lait* interplaying with the white-on-black graphics. The yellow banner also serves to highlight the title.

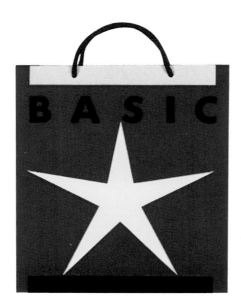

▲ Simple geometric shapes and typeface in black and process yellow form a sophisticated image when applied to terracotta. Juxtaposed with the subtle, muted tones of terracotta, this aggressive shade of yellow becomes surprisingly warm.

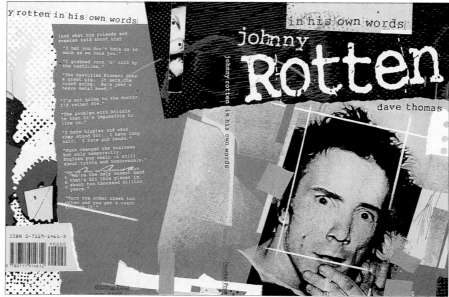

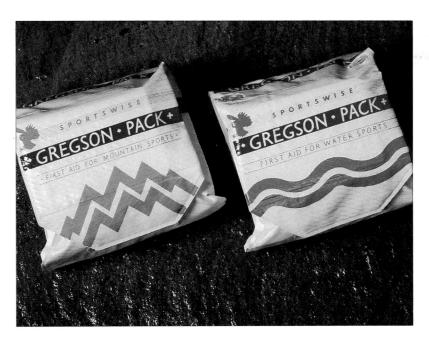

◄ Primary yellow makes an effective background for the associated symbols of blue for water and green for mountain foliage. The yellow not only provides a continuity of packaging but also has a practical purpose, as it is highly visible in an emergency.

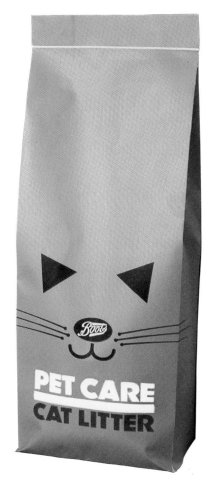

◄ Process yellow forms a blatant background while the subtlest of violet graphics brings texture to the book cover. Demarcation of areas within a narrow border provides visual stimulation through the interplay between tones of sepia yellow and violet. In this instance the roles are reversed and violet becomes dominant. The tantalizing glimpse of graphics relates to the black type on the taupe and sepia tints.

▲ Process yellow lettering attracts attention and, combined with grass green, creates a clean, fresh impression. The yellow strengthens the green without swamping the black cat graphics.

50Y · 10M

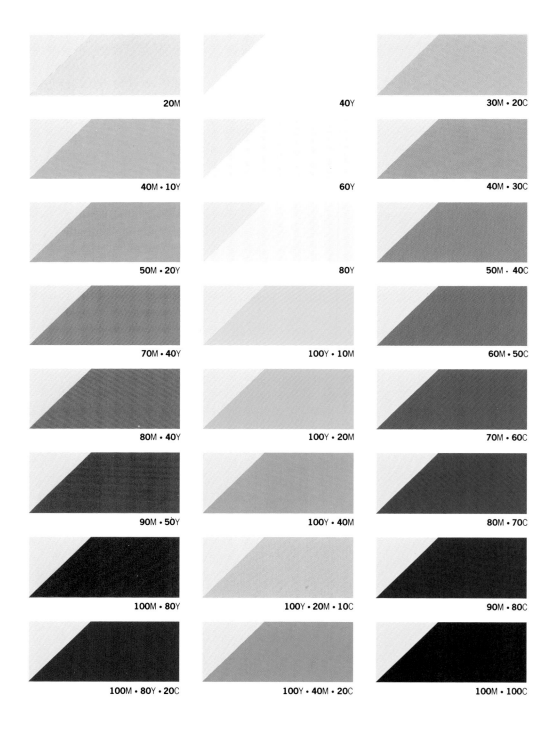

20M

40Y

30M · 20C

40M · 10Y

60Y

40M · 30C

50M · 20Y

80Y

50M · 40C

70M · 40Y

100Y · 10M

60M · 50C

80M · 40Y

100Y · 20M

70M · 60C

90M · 50Y

100Y · 40M

80M · 70C

100M · 80Y

100Y · 20M · 10C

90M · 80C

100M · 80Y · 20C

100Y · 40M · 20C

100M · 100C

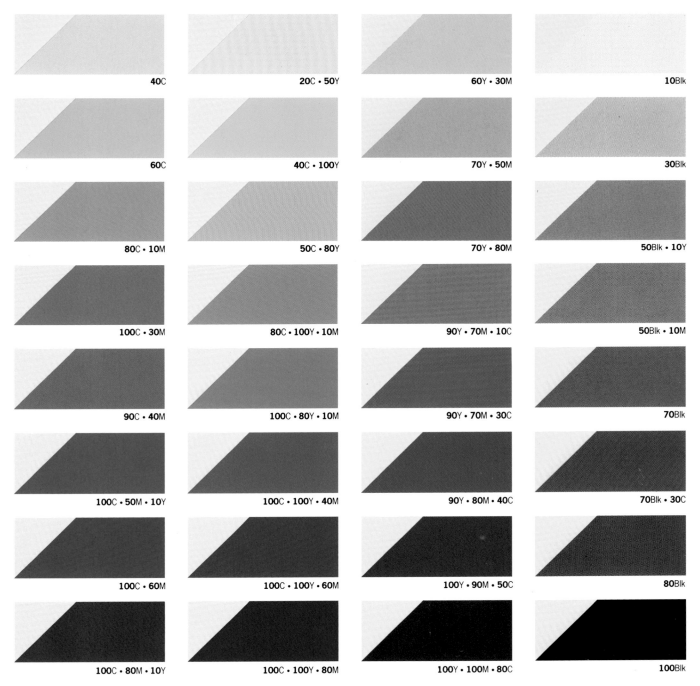

40C	20C · 50Y	60Y · 30M	10Blk
60C	40C · 100Y	70Y · 50M	30Blk
80C · 10M	50C · 80Y	70Y · 80M	50Blk · 10Y
100C · 30M	80C · 100Y · 10M	90Y · 70M · 10C	50Blk · 10M
90C · 40M	100C · 80Y · 10M	90Y · 70M · 30C	70Blk
100C · 50M · 10Y	100C · 100Y · 40M	90Y · 80M · 40C	70Blk · 30C
100C · 60M	100C · 100Y · 60M	100Y · 90M · 50C	80Blk
100C · 80M · 10Y	100C · 100Y · 80M	100Y · 100M · 80C	100Blk

50Y · **10**M

NOTE: For technical information see page 6

100

90

80

Ossidet sterio binignuis tultia, dolorat isogult it gignuntisin stinuand. Flourida prat gereafiunt quaecumque trutent artsquati, quiateire lurorist de corspore orum semi uitantque tueri; sol etiam caecat contra osidetsal utiquite

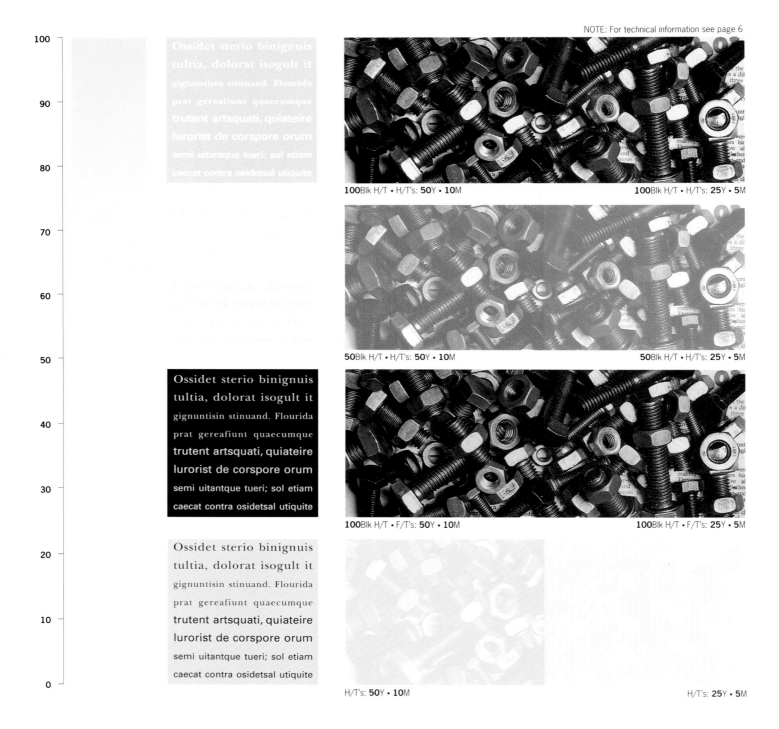

100Blk H/T · H/T's: **50**Y · **10**M 100Blk H/T · H/T's: **25**Y · **5**M

70

60

50Blk H/T · H/T's: **50**Y · **10**M 50Blk H/T · H/T's: **25**Y · **5**M

50

Ossidet sterio binignuis tultia, dolorat isogult it gignuntisin stinuand. Flourida prat gereafiunt quaecumque trutent artsquati, quiateire lurorist de corspore orum semi uitantque tueri; sol etiam caecat contra osidetsal utiquite

40

30

100Blk H/T · F/T's: **50**Y · **10**M 100Blk H/T · F/T's: **25**Y · **5**M

20

Ossidet sterio binignuis tultia, dolorat isogult it gignuntisin stinuand. Flourida prat gereafiunt quaecumque trutent artsquati, quiateire lurorist de corspore orum semi uitantque tueri; sol etiam caecat contra osidetsal utiquite

10

0

H/T's: **50**Y · **10**M H/T's: **25**Y · **5**M

100Y · 30M

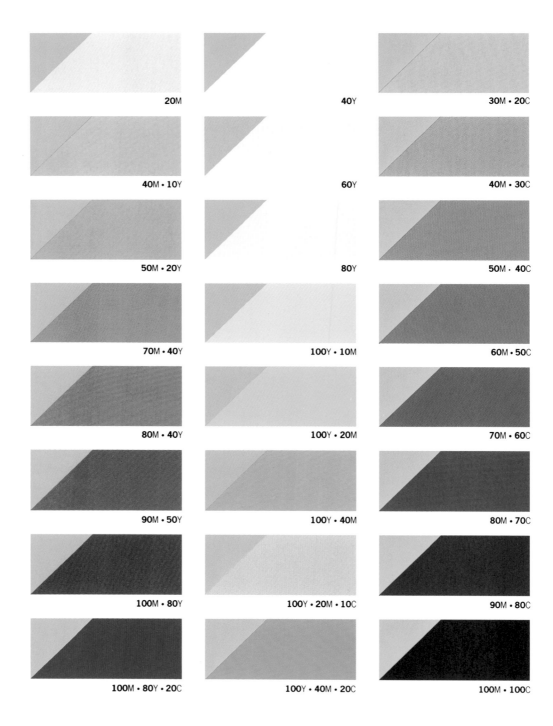

20M

40Y

30M · 20C

40M · 10Y

60Y

40M · 30C

50M · 20Y

80Y

50M · 40C

70M · 40Y

100Y · 10M

60M · 50C

80M · 40Y

100Y · 20M

70M · 60C

90M · 50Y

100Y · 40M

80M · 70C

100M · 80Y

100Y · 20M · 10C

90M · 80C

100M · 80Y · 20C

100Y · 40M · 20C

100M · 100C

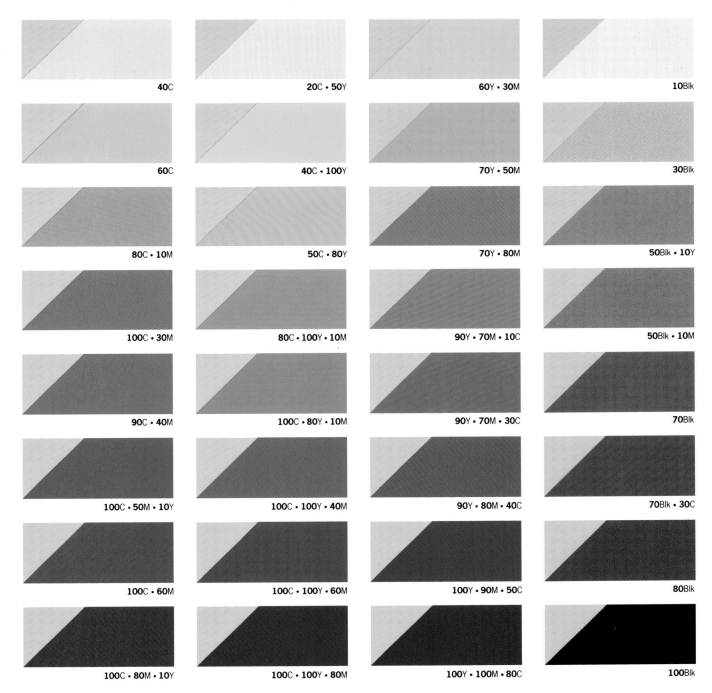

40C	20C · 50Y	60Y · 30M	10Blk
60C	40C · 100Y	70Y · 50M	30Blk
80C · 10M	50C · 80Y	70Y · 80M	50Blk · 10Y
100C · 30M	80C · 100Y · 10M	90Y · 70M · 10C	50Blk · 10M
90C · 40M	100C · 80Y · 10M	90Y · 70M · 30C	70Blk
100C · 50M · 10Y	100C · 100Y · 40M	90Y · 80M · 40C	70Blk · 30C
100C · 60M	100C · 100Y · 60M	100Y · 90M · 50C	80Blk
100C · 80M · 10Y	100C · 100Y · 80M	100Y · 100M · 80C	100Blk

100Y · 30M

NOTE: For technical information see page 6

Ossidet sterio binignuis
tultia, dolorat isogult it
gignuntisin stinuand. Flourida
prat gereafiunt quaecumque
trutent artsquati, quiateire
lurorist de corspore orum
semi uitantque tueri; sol etiam
caecat contra osidetsal utiquite

Ossidet sterio binignuis
tultia, dolorat isogult it
gignuntisin stinuand. Flourida
prat gereafiunt quaecumque
trutent artsquati, quiateire
lurorist de corspore orum
semi uitantque tueri; sol etiam
caecat contra osidetsal utiquite

Ossidet sterio binignuis
tultia, dolorat isogult it
gignuntisin stinuand. Flourida
prat gereafiunt quaecumque
trutent artsquati, quiateire
lurorist de corspore orum
semi uitantque tueri; sol etiam
caecat contra osidetsal utiquite

Ossidet sterio binignuis
tultia, dolorat isogult it
gignuntisin stinuand. Flourida
prat gereafiunt quaecumque
trutent artsquati, quiateire
lurorist de corspore orum
semi uitantque tueri; sol etiam
caecat contra osidetsal utiquite

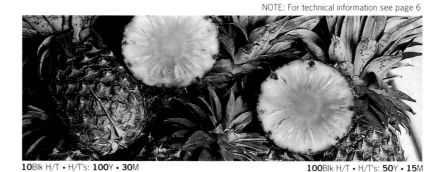

10Blk H/T · H/T's: **100**Y · **30**M 100Blk H/T · H/T's: **50**Y · **15**M

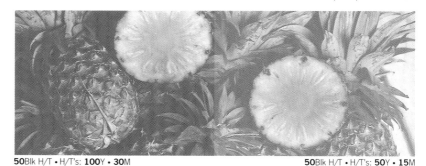

50Blk H/T · H/T's: **100**Y · **30**M 50Blk H/T · H/T's: **50**Y · **15**M

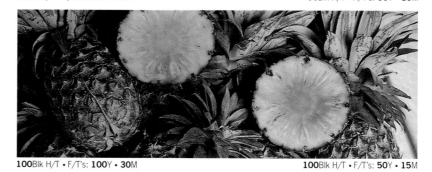

100Blk H/T · F/T's: **100**Y · **30**M 100Blk H/T · F/T's: **50**Y · **15**M

H/T's: **100**Y · **30**M H/T's: **50**Y · **15**M

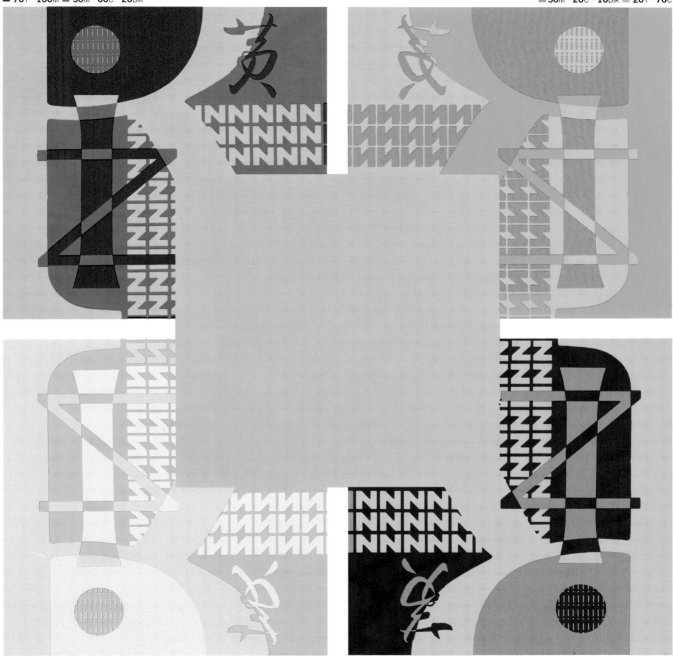

100Y · 50M

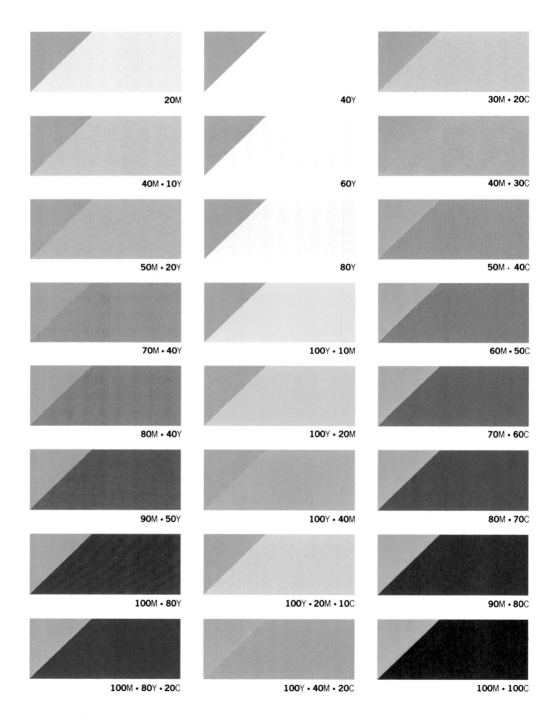

20M

40Y

30M · 20C

40M · 10Y

60Y

40M · 30C

50M · 20Y

80Y

50M · 40C

70M · 40Y

100Y · 10M

60M · 50C

80M · 40Y

100Y · 20M

70M · 60C

90M · 50Y

100Y · 40M

80M · 70C

100M · 80Y

100Y · 20M · 10C

90M · 80C

100M · 80Y · 20C

100Y · 40M · 20C

100M · 100C

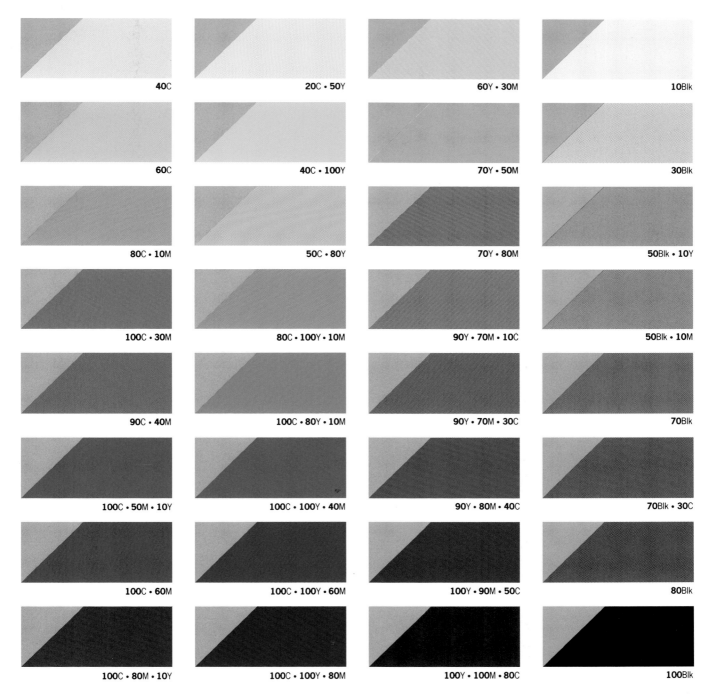

40C	20C · 50Y	60Y · 30M	10Blk
60C	40C · 100Y	70Y · 50M	30Blk
80C · 10M	50C · 80Y	70Y · 80M	50Blk · 10Y
100C · 30M	80C · 100Y · 10M	90Y · 70M · 10C	50Blk · 10M
90C · 40M	100C · 80Y · 10M	90Y · 70M · 30C	70Blk
100C · 50M · 10Y	100C · 100Y · 40M	90Y · 80M · 40C	70Blk · 30C
100C · 60M	100C · 100Y · 60M	100Y · 90M · 50C	80Blk
100C · 80M · 10Y	100C · 100Y · 80M	100Y · 100M · 80C	100Blk

NOTE: For technical information see page 6

100 — 90 — 80 — 70 — 60 — 50 — 40 — 30 — 20 — 10 — 0

Ossidet sterio binignuis
tultia, dolorat isogult it
gignuntisin stinuand. Flourida
prat gereafiunt quaecumque
trutent artsquati, quiateire
lurorist de corspore orum
semi uitantque tueri; sol etiam
caecat contra osidetsal utiquite

Ossidet sterio binignuis
tultia, dolorat isogult it
gignuntisin stinuand. Flourida
prat gereafiunt quaecumque
trutent artsquati, quiateire
lurorist de corspore orum
semi uitantque tueri; sol etiam
caecat contra osidetsal utiquite

Ossidet sterio binignuis
tultia, dolorat isogult it
gignuntisin stinuand. Flourida
prat gereafiunt quaecumque
trutent artsquati, quiateire
lurorist de corspore orum
semi uitantque tueri; sol etiam
caecat contra osidetsal utiquite

Ossidet sterio binignuis
tultia, dolorat isogult it
gignuntisin stinuand. Flourida
prat gereafiunt quaecumque
trutent artsquati, quiateire
lurorist de corspore orum
semi uitantque tueri; sol etiam
caecat contra osidetsal utiquite

100Blk H/T · H/T's: **100**Y · **50**M 100Blk H/T · H/T's: **50**Y · **25**M

50Blk H/T · H/T's: **100**Y · **50**M 50Blk H/T · H/T's: **50**Y · **25**M

100Blk H/T · F/T's: **100**Y · **50**M 100Blk H/T · F/T's: **50**Y · **25**M

H/T's: **100**Y · **50**M H/T's: **50**Y · **25**M

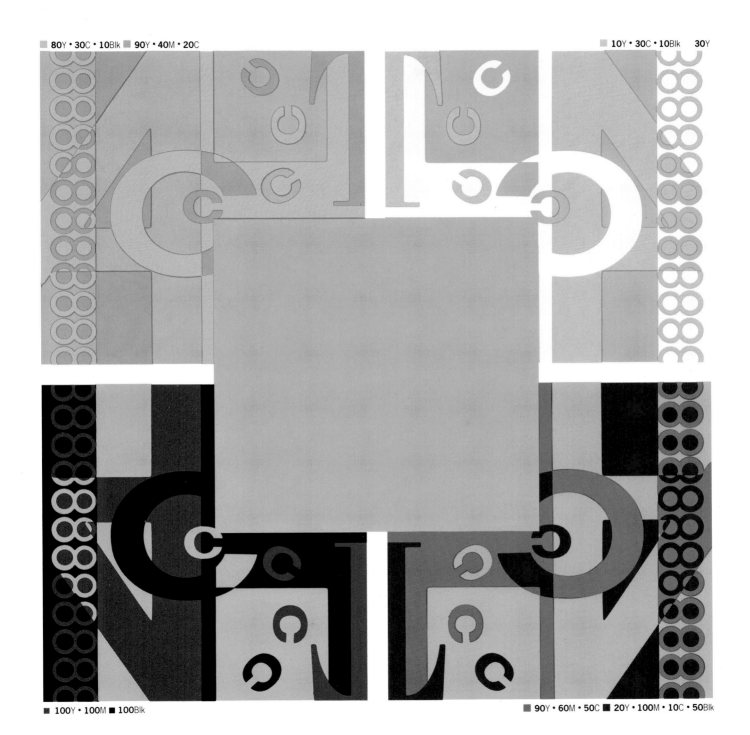

80Y • 30C • 10Blk 90Y • 40M • 20C

10Y • 30C • 10Blk 30Y

100Y • 100M • 100Blk

90Y • 60M • 50C 20Y • 100M • 10C • 50Blk

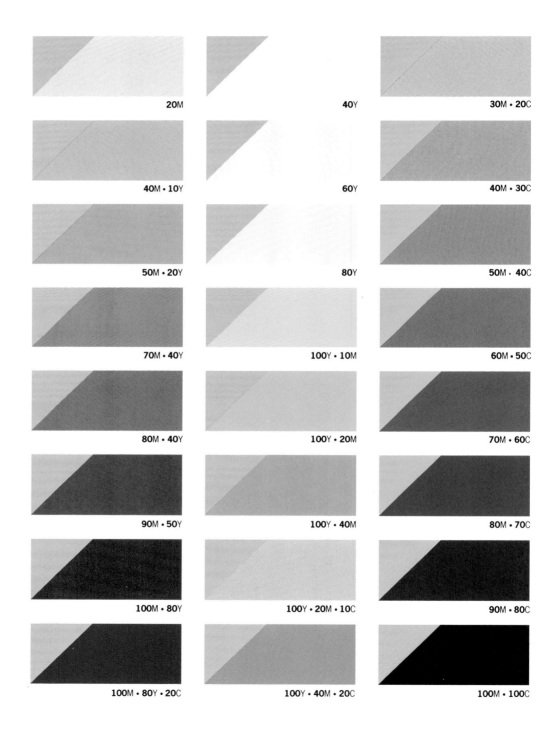

20M

40Y

30M · 20C

40M · 10Y

60Y

40M · 30C

50M · 20Y

80Y

50M · 40C

70M · 40Y

100Y · 10M

60M · 50C

80M · 40Y

100Y · 20M

70M · 60C

90M · 50Y

100Y · 40M

80M · 70C

100M · 80Y

100Y · 20M · 10C

90M · 80C

100M · 80Y · 20C

100Y · 40M · 20C

100M · 100C

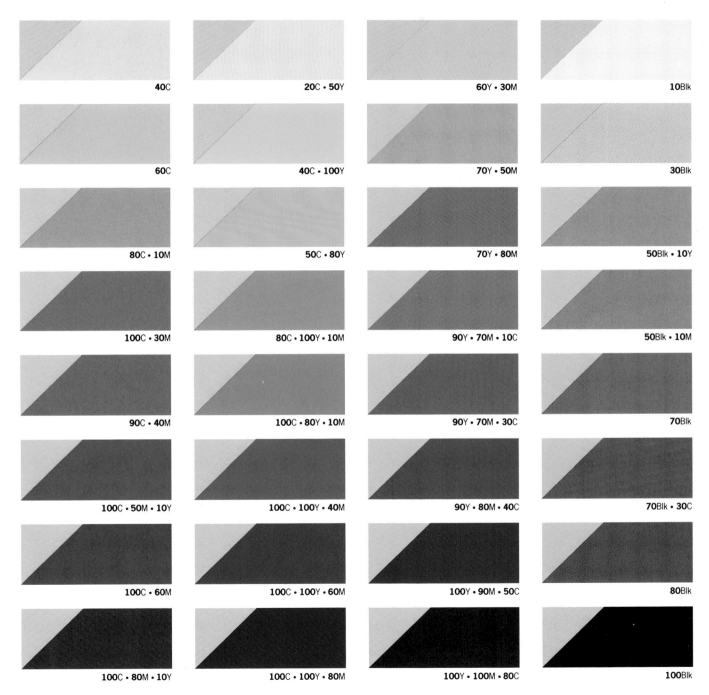

40C	20C • 50Y	60Y • 30M	10Blk
60C	40C • 100Y	70Y • 50M	30Blk
80C • 10M	50C • 80Y	70Y • 80M	50Blk • 10Y
100C • 30M	80C • 100Y • 10M	90Y • 70M • 10C	50Blk • 10M
90C • 40M	100C • 80Y • 10M	90Y • 70M • 30C	70Blk
100C • 50M • 10Y	100C • 100Y • 40M	90Y • 80M • 40C	70Blk • 30C
100C • 60M	100C • 100Y • 60M	100Y • 90M • 50C	80Blk
100C • 80M • 10Y	100C • 100Y • 80M	100Y • 100M • 80C	100Blk

70Y · 30M

NOTE: For technical information see page 6

Ossidet sterio binignuis
tultia, dolorat isogult it
gignuntisin stinuand. Flourida
prat gereafiunt quaecumque
trutent artsquati, quiateire
lurorist de corspore orum
semi uitantque tueri; sol etiam
caecat contra osidetsal utiquite

100Blk H/T • H/T's: **70**Y • **30**M 100Blk H/T • H/T's: **35**Y • **15**M

Ossidet sterio binignuis
tultia, dolorat isogult it
gignuntisin stinuand. Flourida
prat gereafiunt quaecumque
trutent artsquati, quiateire
lurorist de corspore orum
semi uitantque tueri; sol etiam
caecat contra osidetsal utiquite

50Blk H/T • H/T's: **70**Y • **30**M 50Blk H/T • H/T's: **35**Y • **15**M

Ossidet sterio binignuis
tultia, dolorat isogult it
gignuntisin stinuand. Flourida
prat gereafiunt quaecumque
trutent artsquati, quiateire
lurorist de corspore orum
semi uitantque tueri; sol etiam
caecat contra osidetsal utiquite

100Blk H/T • F/T's: **70**Y • **30**M 100Blk H/T • F/T's: **35**Y • **15**M

Ossidet sterio binignuis
tultia, dolorat isogult it
gignuntisin stinuand. Flourida
prat gereafiunt quaecumque
trutent artsquati, quiateire
lurorist de corspore orum
semi uitantque tueri; sol etiam
caecat contra osidetsal utiquite

H/T's: **70**Y • **30**M H/T's: **35**Y • **15**M

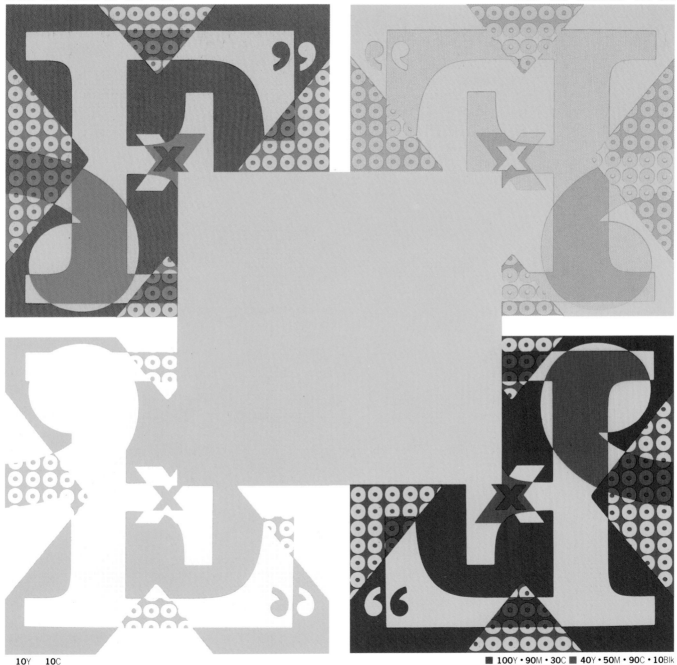

■ 60M • 30C • 20Blk ■ 40Y • 70C • 20Blk

■ 20Y • 10M • 30Blk ■ 20Y • 10M • 30C

10Y 10C

■ 100Y • 90M • 30C ■ 40Y • 50M • 90C • 10Blk

Shades of a sunburst, from ripe orange through golden yellow to palest apricot, create a natural palette. These tones blend with one another and complement all other natural tones.

▶ The flowing movement of the ochre and black illustration is picked up in the formal typography of the documentation. Using this ochred yellow for the headings breaks the consistency of the black type in this brave deviation from the standard company report.

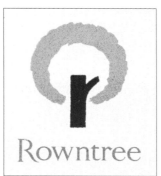

▲ A round tree in its simplest form becomes the Rowntree candy logo. It is given childlike abstraction with a complex colour composition. Golden yellow teamed with rich terracotta reproduces the colouring of nature, confirming the image of the logo. These strong shades perform the task of primary colours without the brashness.

▼ The expansive golden fields and wide blue skies provide the story behind the caption, further emphasized by the Indian yellow of the dropped capital in the typography. The rich saffron shades reinforce the connotations of abundance in a ripe golden harvest.

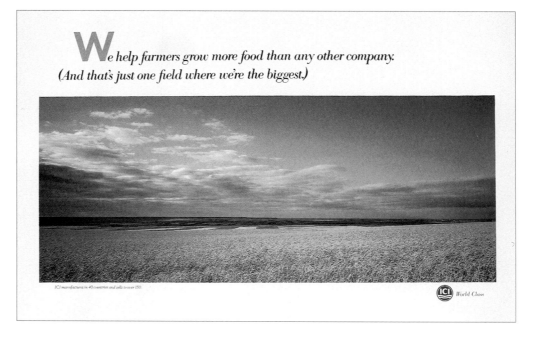

We help farmers grow more food than any other company. (And that's just one field where we're the biggest.)

ICI manufactures in 40 countries and sells to over 150.

ICI World Class

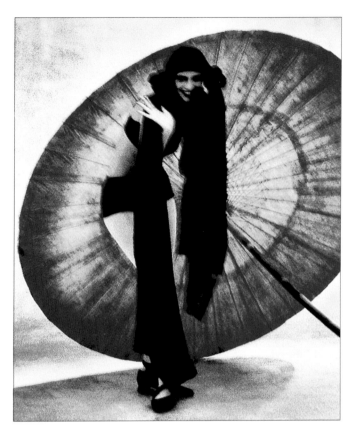

◄ Shades of burnt orange and golden yellow filter through the parasol, producing a glowing backdrop to the classic 1920s figure. The orientally inspired style and posture reinforce the symbolic sun shape of the glowing parasol. The haze from the orange and yellow absorbs the flesh tones and softens the black to create an indistinct finish. Set against a wash of pale blue, the sunshade becomes the dominant object, while the eye is drawn to the central black-draped figure.

▲ A complex diagram in an academic book forms part of an overall graphic design which relies on a subtle and discreet use of colour for its effectiveness. The greyed lilac of the illustration and the minimal black graphics are given warmth and interest by the mandarin yellow.

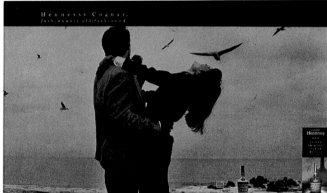

FOR FINANCIAL INFORMATION. THE LAST WORD IN DETAIL.

Information. You want it. Detailed, concise and before anyone else. Financial Times Newsletters have it. A regularly updated picture of world finance in pin-sharp focus. Hard facts from international sources, illuminated by our top analysts and commentators. This is the information that gives you the edge. *ftbi*

◄ The wealth of gold is the overpowering statement in this dominantly yellow advertisement. The rich saffron background behind the text allows the softer gold shades of the coins to glow gently in shafts of white light. This rich shade of yellow also gives clarity to the black typography and enhances visibility.

▲ The use of a sienna tint for this highly evocative photograph not only creates the atmosphere of a sybaritic late afternoon picnic but also echoes the colour of cognac. The warmth of this shade is underlined by red, while the discreet black background projects the white typography and reinforces the image of adult sophistication.

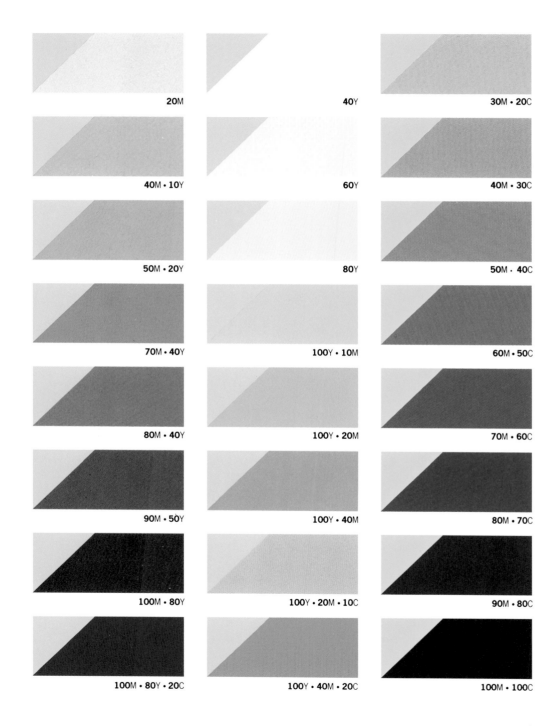

20M

40Y

30M · 20C

40M · 10Y

60Y

40M · 30C

50M · 20Y

80Y

50M · 40C

70M · 40Y

100Y · 10M

60M · 50C

80M · 40Y

100Y · 20M

70M · 60C

90M · 50Y

100Y · 40M

80M · 70C

100M · 80Y

100Y · 20M · 10C

90M · 80C

100M · 80Y · 20C

100Y · 40M · 20C

100M · 100C

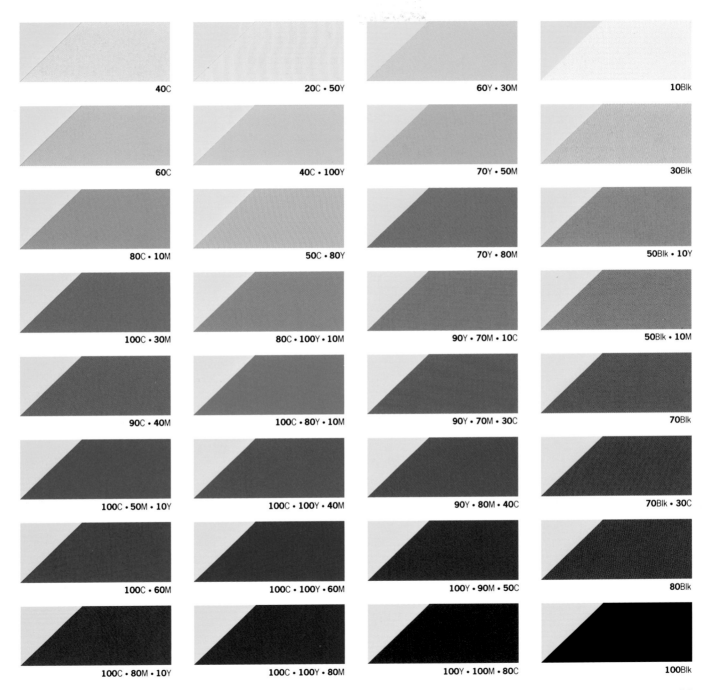

40C

20C · 50Y

60Y · 30M

10Blk

60C

40C · 100Y

70Y · 50M

30Blk

80C · 10M

50C · 80Y

70Y · 80M

50Blk · 10Y

100C · 30M

80C · 100Y · 10M

90Y · 70M · 10C

50Blk · 10M

90C · 40M

100C · 80Y · 10M

90Y · 70M · 30C

70Blk

100C · 50M · 10Y

100C · 100Y · 40M

90Y · 80M · 40C

70Blk · 30C

100C · 60M

100C · 100Y · 60M

100Y · 90M · 50C

80Blk

100C · 80M · 10Y

100C · 100Y · 80M

100Y · 100M · 80C

100Blk

NOTE: For technical information see page 6

100

90

80

70

60

50

40

30

20

10

0

Ossidet sterio binignuis
tultia, dolorat isogult it
gignuntisin stinuand. Flourida
prat gereafiunt quaecumque
trutent artsquati, quiateire
lurorist de corspore orum
semi uitantque tueri; sol etiam
caecat contra osidetsal utiquite

Ossidet sterio binignuis
tultia, dolorat isogult it
gignuntisin stinuand. Flourida
prat gereafiunt quaecumque
trutent artsquati, quiateire
lurorist de corspore orum
semi uitantque tueri; sol etiam
caecat contra osidetsal utiquite

Ossidet sterio binignuis
tultia, dolorat isogult it
gignuntisin stinuand. Flourida
prat gereafiunt quaecumque
trutent artsquati, quiateire
lurorist de corspore orum
semi uitantque tueri; sol etiam
caecat contra osidetsal utiquite

Ossidet sterio binignuis
tultia, dolorat isogult it
gignuntisin stinuand. Flourida
prat gereafiunt quaecumque
trutent artsquati, quiateire
lurorist de corspore orum
semi uitantque tueri; sol etiam
caecat contra osidetsal utiquite

100Blk H/T • H/T's: **100**Y • **10**M 100Blk H/T • H/T's: **50**Y • **5**M

50Blk H/T • H/T's: **100**Y • **10**M 50Blk H/T • H/T's: **50**Y • **5**M

100Blk H/T • F/T's: **100**Y • **10**M 100Blk H/T • F/T's: **50**Y • **5**M

H/T's: **100**Y • **10**M H/T's: **50**Y • **5**M

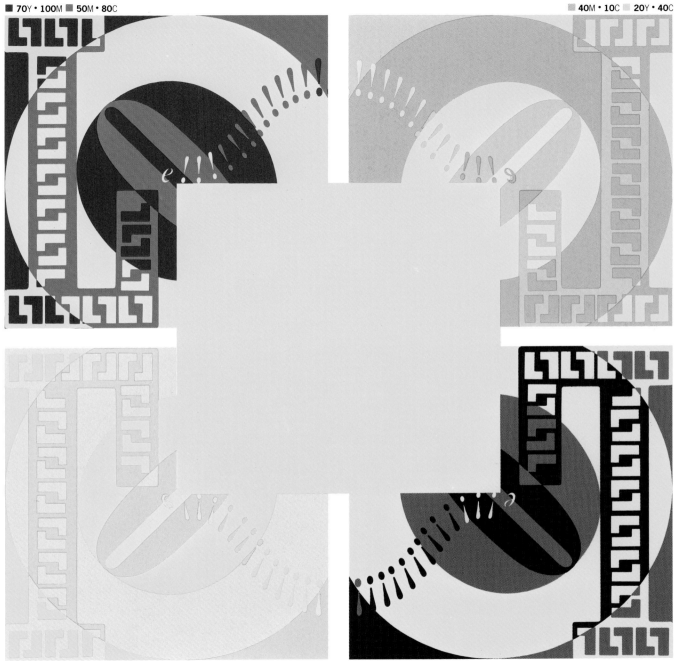

■ 70Y • 100M ■ 50M • 80C

□ 40M • 10C □ 20Y • 40C

□ 10Y • 20M □ 10Y • 40C

■ 20Y • 50M • 60C • 20Blk ■ 20Y • 100M • 40C • 40Blk

Sunflowers, fields of wheat and hot summer days are evoked by the simplest and yet most powerful of yellows. This highly visible, rich, warm chrome complements other shades.

▶ Corporate identity and continuity are developed through the typography of these three brochures. The colours have an alert, pure style, using a role-reversal of hue. Powder blue on sunflower yellow has a jarring effect when used in this way, as the more obvious application would be yellow on blue.

◀ Strong shades of chrome yellow and leaf green form the basis for a company logo aimed at parents and children. The teaming of yellow and green has a natural association with the growth of plants, which relates in turn to growing children and the need for new shoes. The green background projects the rich yellow typography, giving visibility while creating a friendly, young image. The extreme simplicity of the design allows the colours to tell their story.

▶ An imaginative colour palette is adapted to create a positive company identity which is both memorable and distinctive, without losing aesthetic appeal. Chrome yellow is the most visible of all the colours and has been appropriately applied to dominate wherever it is positioned within the designs. The chrome and terracotta tonally complement each other while contrasting against the soft black, while *eau-de-nil* is used as an additional highlight.

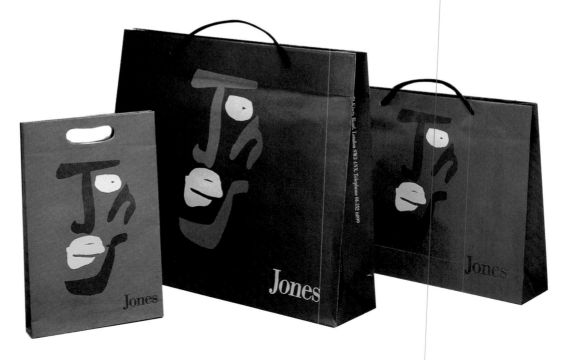

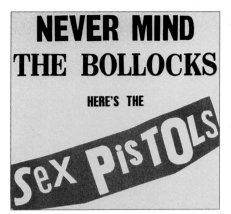

► A bold statement is made by the powerful combination of chrome yellow and black. The large area of yellow gives clear visibility to typography and photography, while the black geometric shapes recede. A basically simple, yet effective approach to both design and colour is given an interesting dimension by introducing cyan.

▲ An anarchic colour combination is used to recreate the sounds of the record. The strident yellow background projects the bold black typography, while the magenta banner blatantly displays an irregular chrome yellow typeface. The clashing fluorescent effect of the yellow and shocking pink, used so effectively by Warhol, is both discordant and memorable.

▼ The yellow bands and chrome yellow label behind the black type denote Schweppes and suggest the bright, fresh flavour. The yellow image is further strengthened by the twist of lemon threading through the bubbles.

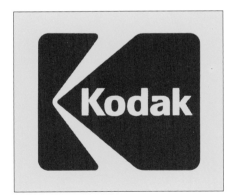

▲ Kodak's use of chrome yellow in its corporate logo makes its products instantly recognizable. The rich yellow background contains the solid red graphics, and yet when the chrome typography is applied to the primary red the company name is projected.

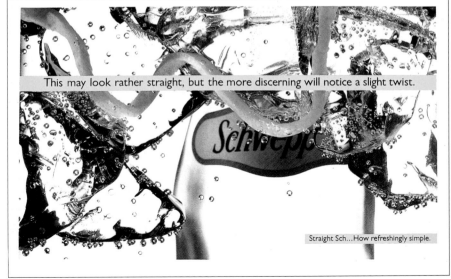

This may look rather straight, but the more discerning will notice a slight twist.

Straight Sch…How refreshingly simple.

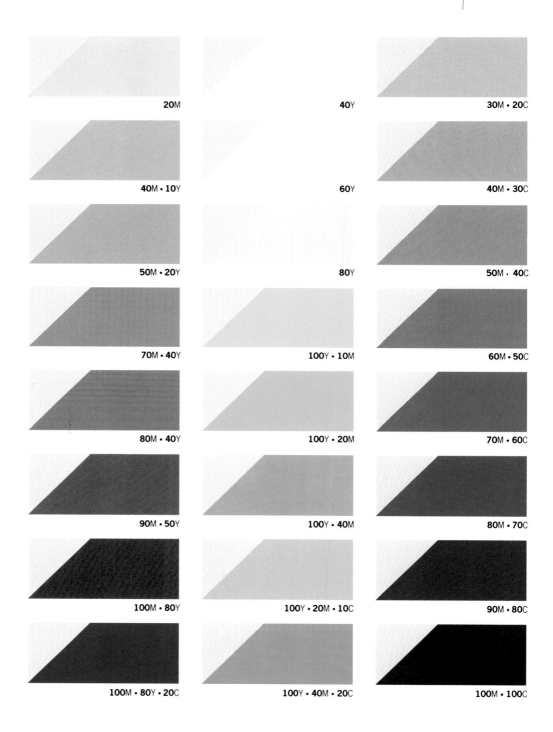

20M

40Y

30M · 20C

40M · 10Y

60Y

40M · 30C

50M · 20Y

80Y

50M · 40C

70M · 40Y

100Y · 10M

60M · 50C

80M · 40Y

100Y · 20M

70M · 60C

90M · 50Y

100Y · 40M

80M · 70C

100M · 80Y

100Y · 20M · 10C

90M · 80C

100M · 80Y · 20C

100Y · 40M · 20C

100M · 100C

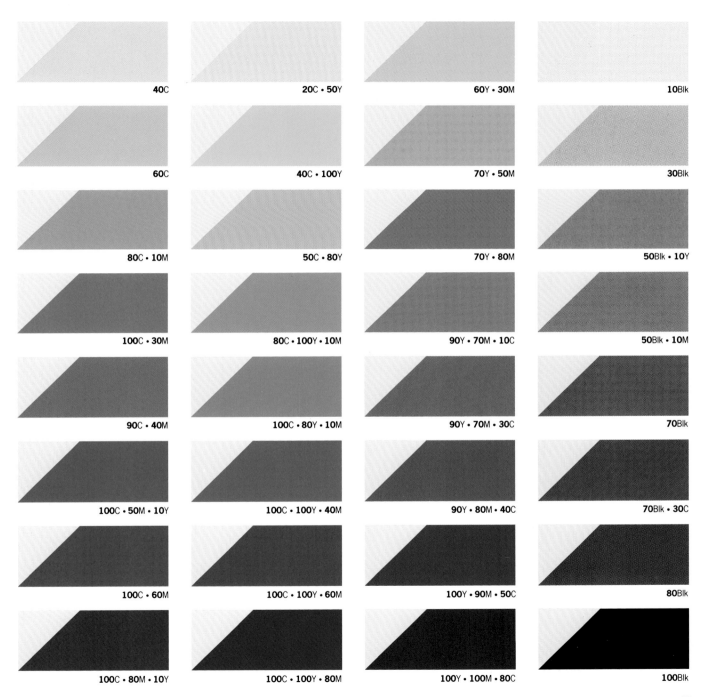

40C

20C · 50Y

60Y · 30M

10Blk

60C

40C · 100Y

70Y · 50M

30Blk

80C · 10M

50C · 80Y

70Y · 80M

50Blk · 10Y

100C · 30M

80C · 100Y · 10M

90Y · 70M · 10C

50Blk · 10M

90C · 40M

100C · 80Y · 10M

90Y · 70M · 30C

70Blk

100C · 50M · 10Y

100C · 100Y · 40M

90Y · 80M · 40C

70Blk · 30C

100C · 60M

100C · 100Y · 60M

100Y · 90M · 50C

80Blk

100C · 80M · 10Y

100C · 100Y · 80M

100Y · 100M · 80C

100Blk

70Y · 10C

NOTE: For technical information see page 6

Ossidet sterio binignuis
tultia, dolorat isogult it
gignuntisin stinuand. Flourida
prat gereafiunt quaecumque
trutent artsquati, quiateire
lurorist de corspore orum
semi uitantque tueri; sol etiam
caecat contra osidetsal utiquite

Ossidet sterio binignuis
tultia, dolorat isogult it
gignuntisin stinuand. Flourida
prat gereafiunt quaecumque
trutent artsquati, quiateire
lurorist de corspore orum
semi uitantque tueri; sol etiam
caecat contra osidetsal utiquite

100Blk H/T · H/T's: **70**Y · **10**C 100Blk H/T · H/T's: **35**Y · **5**C

50Blk H/T · H/T's: **70**Y · **10**C 50Blk H/T · H/T's: **35**Y · **5**C

Ossidet sterio binignuis
tultia, dolorat isogult it
gignuntisin stinuand. Flourida
prat gereafiunt quaecumque
trutent artsquati, quiateire
lurorist de corspore orum
semi uitantque tueri; sol etiam
caecat contra osidetsal utiquite

100Blk H/T · F/T's: **70**Y · **10**C 100Blk H/T · F/T's: **35**Y · **5**C

Ossidet sterio binignuis
tultia, dolorat isogult it
gignuntisin stinuand. Flourida
prat gereafiunt quaecumque
trutent artsquati, quiateire
lurorist de corspore orum
semi uitantque tueri; sol etiam
caecat contra osidetsal utiquite

H/T's: **70**Y · **10**C H/T's: **35**Y · **5**C

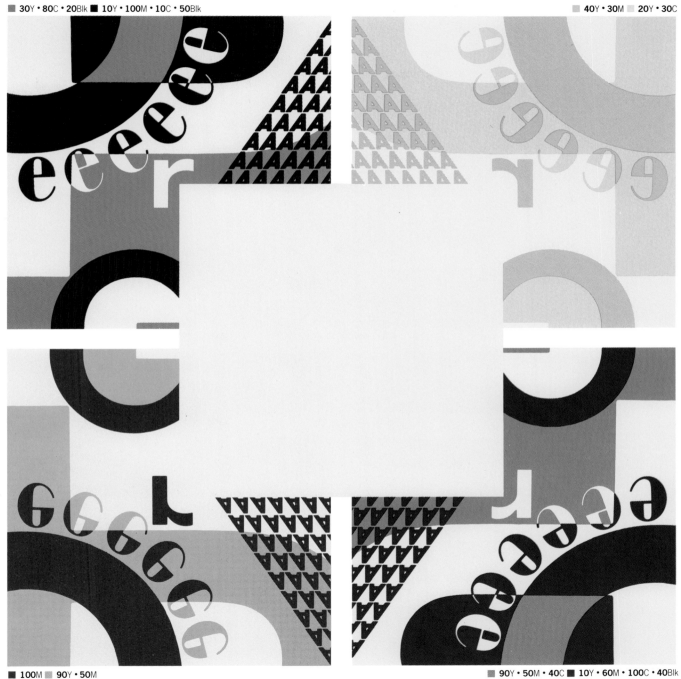

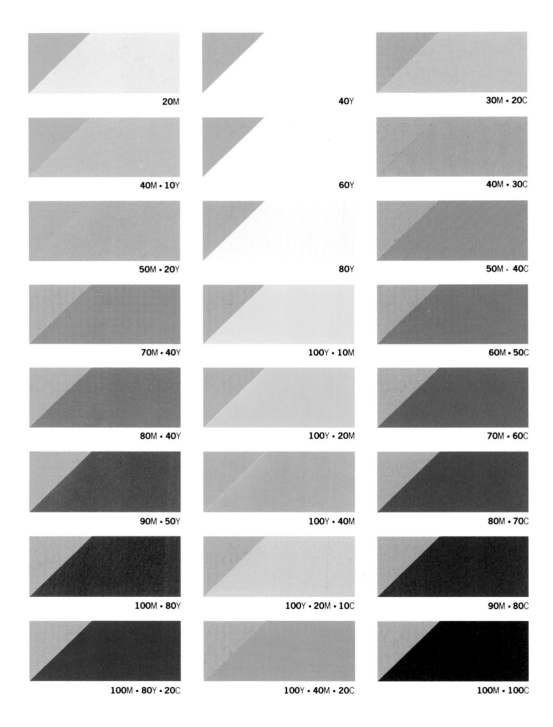

20M

40Y

30M · 20C

40M · 10Y

60Y

40M · 30C

50M · 20Y

80Y

50M · 40C

70M · 40Y

100Y · 10M

60M · 50C

80M · 40Y

100Y · 20M

70M · 60C

90M · 50Y

100Y · 40M

80M · 70C

100M · 80Y

100Y · 20M · 10C

90M · 80C

100M · 80Y · 20C

100Y · 40M · 20C

100M · 100C

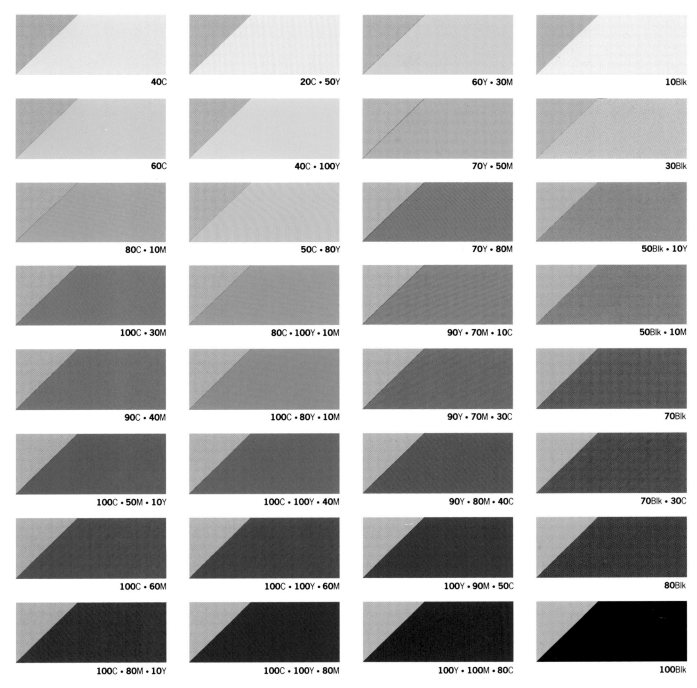

40C

20C • 50Y

60Y • 30M

10Blk

60C

40C • 100Y

70Y • 50M

30Blk

80C • 10M

50C • 80Y

70Y • 80M

50Blk • 10Y

100C • 30M

80C • 100Y • 10M

90Y • 70M • 10C

50Blk • 10M

90C • 40M

100C • 80Y • 10M

90Y • 70M • 30C

70Blk

100C • 50M • 10Y

100C • 100Y • 40M

90Y • 80M • 40C

70Blk • 30C

100C • 60M

100C • 100Y • 60M

100Y • 90M • 50C

80Blk

100C • 80M • 10Y

100C • 100Y • 80M

100Y • 100M • 80C

100Blk

100Y · 30Blk

NOTE: For technical information see page 6

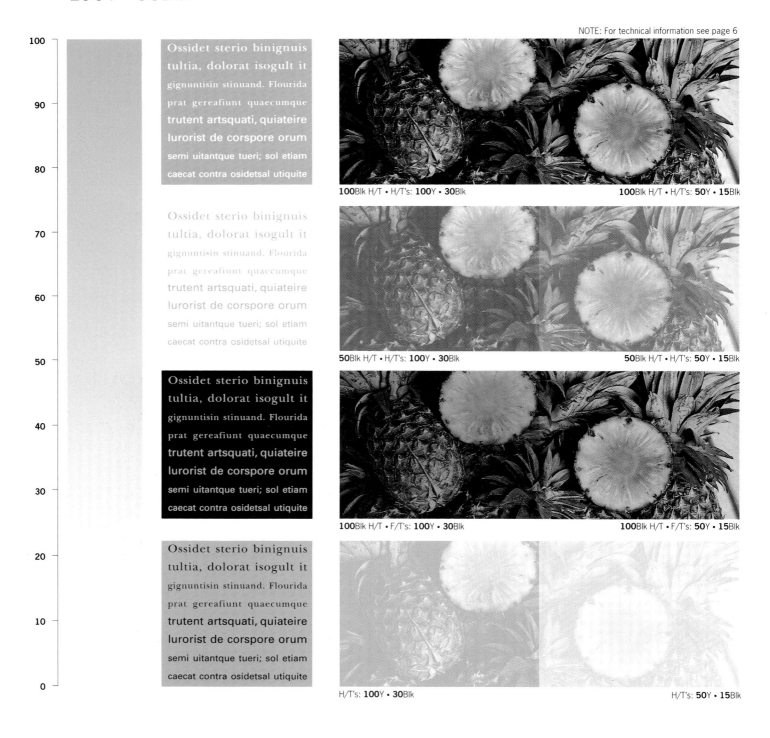

Ossidet sterio binignuis tultia, dolorat isogult it gignuntisin stinuand. Flourida prat gereafiunt quaecumque **trutent artsquati, quiateire lurorist de corspore orum** semi uitantque tueri; sol etiam caecat contra osidetsal utiquite

Ossidet sterio binignuis tultia, dolorat isogult it gignuntisin stinuand. Flourida prat gereafiunt quaecumque **trutent artsquati, quiateire lurorist de corspore orum** semi uitantque tueri; sol etiam caecat contra osidetsal utiquite

Ossidet sterio binignuis tultia, dolorat isogult it gignuntisin stinuand. Flourida prat gereafiunt quaecumque **trutent artsquati, quiateire lurorist de corspore orum** semi uitantque tueri; sol etiam caecat contra osidetsal utiquite

Ossidet sterio binignuis tultia, dolorat isogult it gignuntisin stinuand. Flourida prat gereafiunt quaecumque **trutent artsquati, quiateire lurorist de corspore orum** semi uitantque tueri; sol etiam caecat contra osidetsal utiquite

100Blk H/T • H/T's: **100**Y • **30**Blk 100Blk H/T • H/T's: **50**Y • **15**Blk

50Blk H/T • H/T's: **100**Y • **30**Blk 50Blk H/T • H/T's: **50**Y • **15**Blk

100Blk H/T • F/T's: **100**Y • **30**Blk 100Blk H/T • F/T's: **50**Y • **15**Blk

H/T's: **100**Y • **30**Blk H/T's: **50**Y • **15**Blk

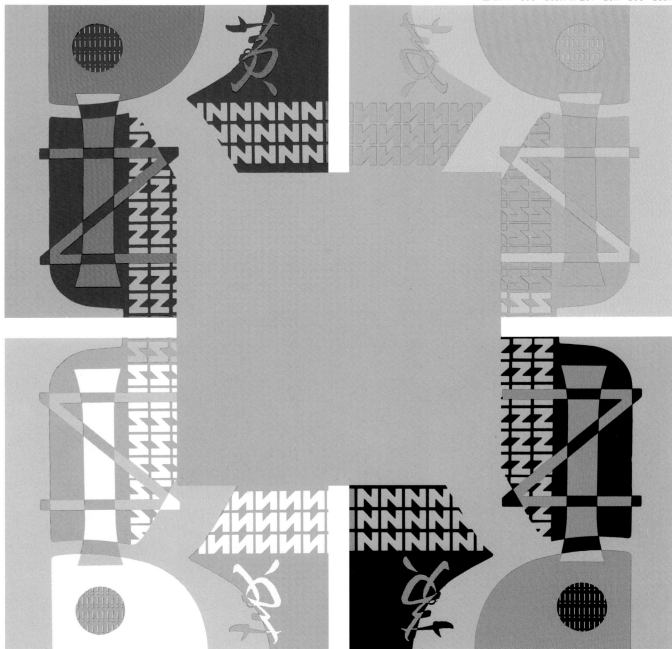

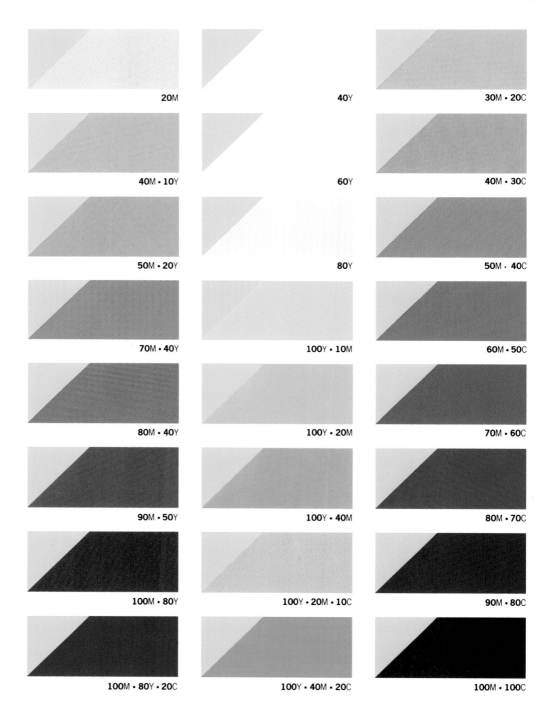

20M

40Y

30M · 20C

40M · 10Y

60Y

40M · 30C

50M · 20Y

80Y

50M · 40C

70M · 40Y

100Y · 10M

60M · 50C

80M · 40Y

100Y · 20M

70M · 60C

90M · 50Y

100Y · 40M

80M · 70C

100M · 80Y

100Y · 20M · 10C

90M · 80C

100M · 80Y · 20C

100Y · 40M · 20C

100M · 100C

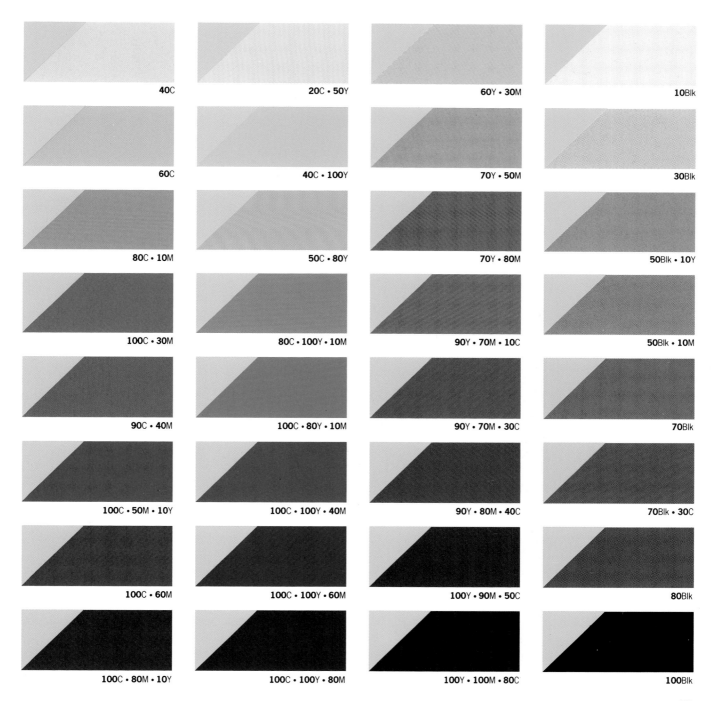

40C

20C • 50Y

60Y • 30M

10Blk

60C

40C • 100Y

70Y • 50M

30Blk

80C • 10M

50C • 80Y

70Y • 80M

50Blk • 10Y

100C • 30M

80C • 100Y • 10M

90Y • 70M • 10C

50Blk • 10M

90C • 40M

100C • 80Y • 10M

90Y • 70M • 30C

70Blk

100C • 50M • 10Y

100C • 100Y • 40M

90Y • 80M • 40C

70Blk • 30C

100C • 60M

100C • 100Y • 60M

100Y • 90M • 50C

80Blk

100C • 80M • 10Y

100C • 100Y • 80M

100Y • 100M • 80C

100Blk

100Y · 30C

NOTE: For technical information see page 6

| 100 |
| 90 |
| 80 |

Ossidet sterio binignuis tultia, dolorat isogult it gignuntisin stinuand. Flourida prat gereafiunt quaecumque trutent artsquati, quiateire lurorist de corspore orum semi uitantque tueri; sol etiam caecat contra osidetsal utiquite

100Blk H/T • H/T's: **100**Y • **30**C 100Blk H/T • H/T's:**50**Y • **15**C

Ossidet sterio binignuis tultia, dolorat isogult it gignuntisin stinuand. Flourida prat gereafiunt quaecumque trutent artsquati, quiateire lurorist de corspore orum semi uitantque tueri; sol etiam caecat contra osidetsal utiquite

50Blk H/T • H/T's: **100**Y • **30**C 50Blk H/T • H/T's:**50**Y • **15**C

Ossidet sterio binignuis tultia, dolorat isogult it gignuntisin stinuand. Flourida prat gereafiunt quaecumque trutent artsquati, quiateire lurorist de corspore orum semi uitantque tueri; sol etiam caecat contra osidetsal utiquite

100Blk H/T • F/T's:**100**Y • **30**C 100Blk H/T • F/T's:**50**Y • **15**C

Ossidet sterio binignuis tultia, dolorat isogult it gignuntisin stinuand. Flourida prat gereafiunt quaecumque trutent artsquati, quiateire lurorist de corspore orum semi uitantque tueri; sol etiam caecat contra osidetsal utiquite

H/T's:**100**Y • **30**C H/T's:**50**Y • **15**C

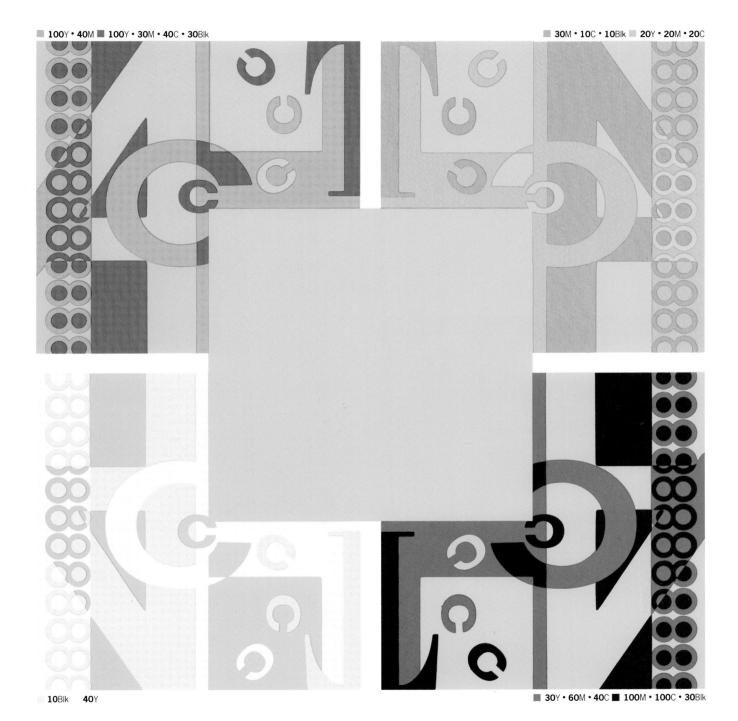

100Y・40M 100Y・30M・40C・30Blk

30M・10C・10Blk 20Y・20M・20C

10Blk 40Y

30Y・60M・40C 100M・100C・30Blk

Zany and offbeat, this colour never behaves. Always contemporary, never conforming, often humorous.

▶ Three shades of green through various intensities provide a colour story of health, strength and vitality. This is reinforced by the stylized graphics and the witty text. Lime yellow brings life and energy to the background figure, which projects the bottle green product. Used in the typography, it provides gentle punctuation for the text and image.

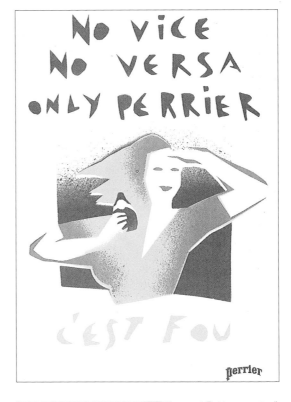

▲ A putrid green forms an appropriate background for such ghoulish graphics. The fluorescent lime is a glowing backdrop, allowing the grotesque images to float amid

the black typography. The luminous shade of green becomes all the more cavernous when placed within black borders.

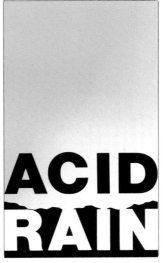

◀ Eighty per cent yellow and twenty per cent black create a perfect shade of acidic yellow, suggestive of acid rain. The strong black and white typography underlines the powerful colour that is the image behind the message.

► A solid lime green image is used to bring life and dimension to hand-printed graphics. This shade gives the typography clarity, and a contemporary flavour.

►► The purity of the yellowed hue brings light to a solid composition, while tonally complementing the saffron of the insects' wings. This unusual combination is given great strength and visibility by using black for the graphics and the bold typography.

◄ The clashing effect of lime green on magenta is intensified because they are complementary colours. The dimensional perspective changes when the colours are reversed. Both colourways provide extreme visibility and fluorescence.

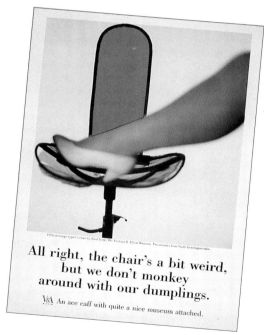

All right, the chair's a bit weird, but we don't monkey around with our dumplings.

V&A An ace caff with quite a nice museum attached.

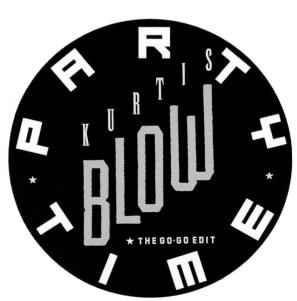

◄ The impact of applying lime green to bold black and white graphics is immediate, projecting the musician's name. The combination of apparently simple graphics, typography and colour creates a complex, memorable cover.

▲ The overt sexuality of the composition, combined with the statement 'The chair's a bit weird', is reinforced by the use of chartreuse for the stockinged leg. This is an unconventional colour which intimates that the wearer is sophisticatedly offbeat.

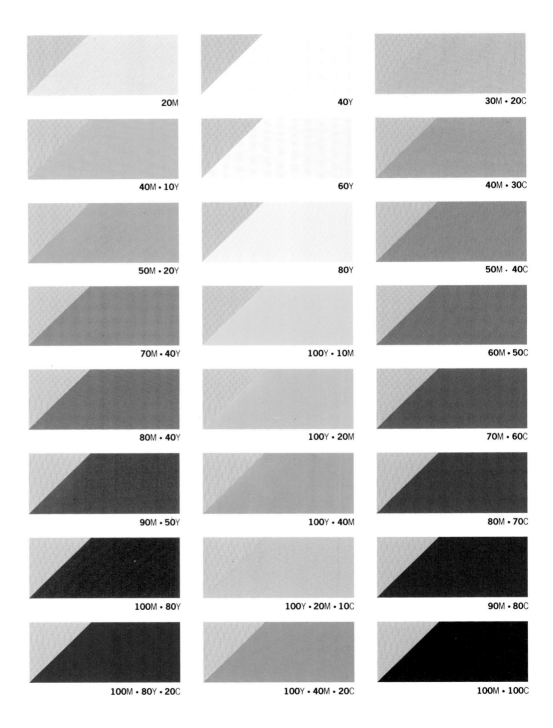

20M

40Y

30M·20C

40M·10Y

60Y

40M·30C

50M·20Y

80Y

50M·40C

70M·40Y

100Y·10M

60M·50C

80M·40Y

100Y·20M

70M·60C

90M·50Y

100Y·40M

80M·70C

100M·80Y

100Y·20M·10C

90M·80C

100M·80Y·20C

100Y·40M·20C

100M·100C

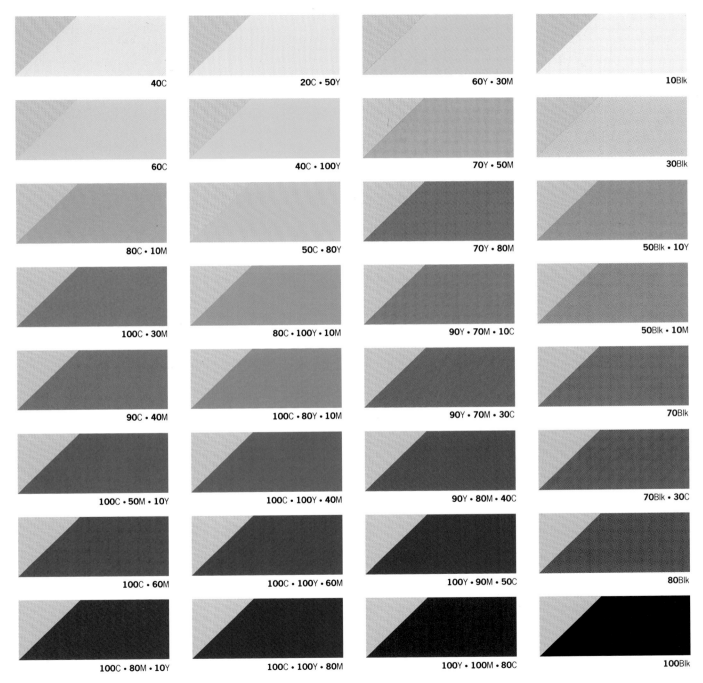

40C

20C • 50Y

60Y • 30M

10Blk

60C

40C • 100Y

70Y • 50M

30Blk

80C • 10M

50C • 80Y

70Y • 80M

50Blk • 10Y

100C • 30M

80C • 100Y • 10M

90Y • 70M • 10C

50Blk • 10M

90C • 40M

100C • 80Y • 10M

90Y • 70M • 30C

70Blk

100C • 50M • 10Y

100C • 100Y • 40M

90Y • 80M • 40C

70Blk • 30C

100C • 60M

100C • 100Y • 60M

100Y • 90M • 50C

80Blk

100C • 80M • 10Y

100C • 100Y • 80M

100Y • 100M • 80C

100Blk

50Y · 50C

NOTE: For technical information see page 6

Ossidet sterio binignuis tultia, dolorat isogult it gignuntisin stinuand. Flourida prat gereafiunt quaecumque **trutent artsquati, quiateire lurorist de corspore orum** semi uitantque tueri; sol etiam caecat contra osidetsal utiquite

100Blk H/T · H/T's: **50**Y · **50**C 100Blk H/T · H/T's: **25**Y · **25**C

Ossidet sterio binignuis tultia, dolorat isogult it gignuntisin stinuand. Flourida prat gereafiunt quaecumque trutent artsquati, quiateire lurorist de corspore orum semi uitantque tueri; sol etiam caecat contra osidetsal utiquite

50Blk H/T · H/T's: **50**Y · **50**C 50Blk H/T · H/T's: **25**Y · **25**C

Ossidet sterio binignuis tultia, dolorat isogult it gignuntisin stinuand. Flourida prat gereafiunt quaecumque **trutent artsquati, quiateire lurorist de corspore orum** semi uitantque tueri; sol etiam caecat contra osidetsal utiquite

100Blk H/T · F/T's: **50**Y · **50**C 100Blk H/T · F/T's: **25**Y · **25**C

Ossidet sterio binignuis tultia, dolorat isogult it gignuntisin stinuand. Flourida prat gereafiunt quaecumque **trutent artsquati, quiateire lurorist de corspore orum** semi uitantque tueri; sol etiam caecat contra osidetsal utiquite

H/T's: **50**Y · **50**C H/T's: **25**Y · **25**C

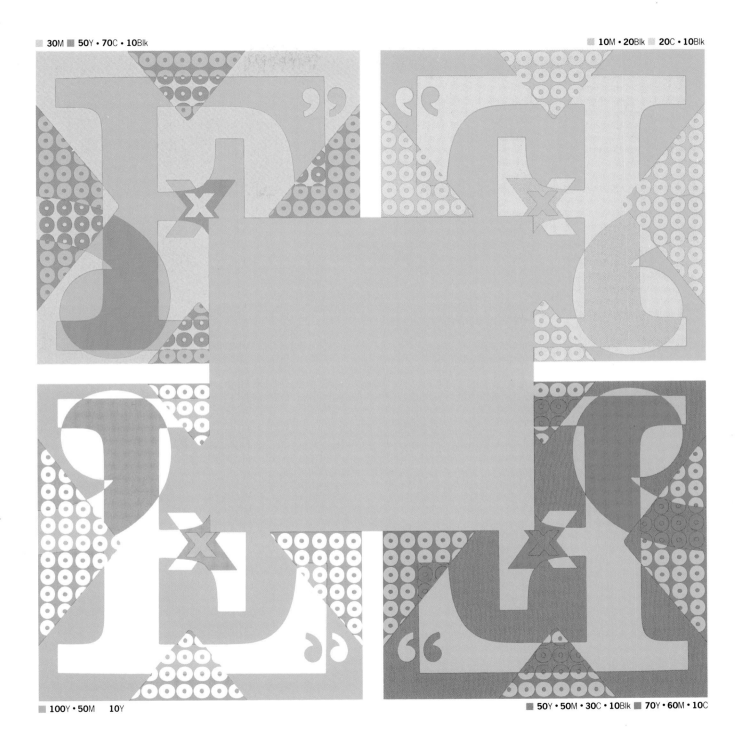

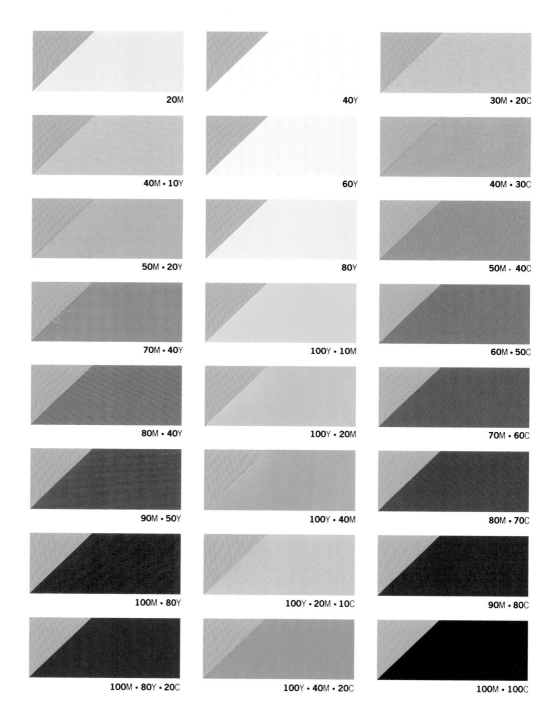

20M

40Y

30M · 20C

40M · 10Y

60Y

40M · 30C

50M · 20Y

80Y

50M · 40C

70M · 40Y

100Y · 10M

60M · 50C

80M · 40Y

100Y · 20M

70M · 60C

90M · 50Y

100Y · 40M

80M · 70C

100M · 80Y

100Y · 20M · 10C

90M · 80C

100M · 80Y · 20C

100Y · 40M · 20C

100M · 100C

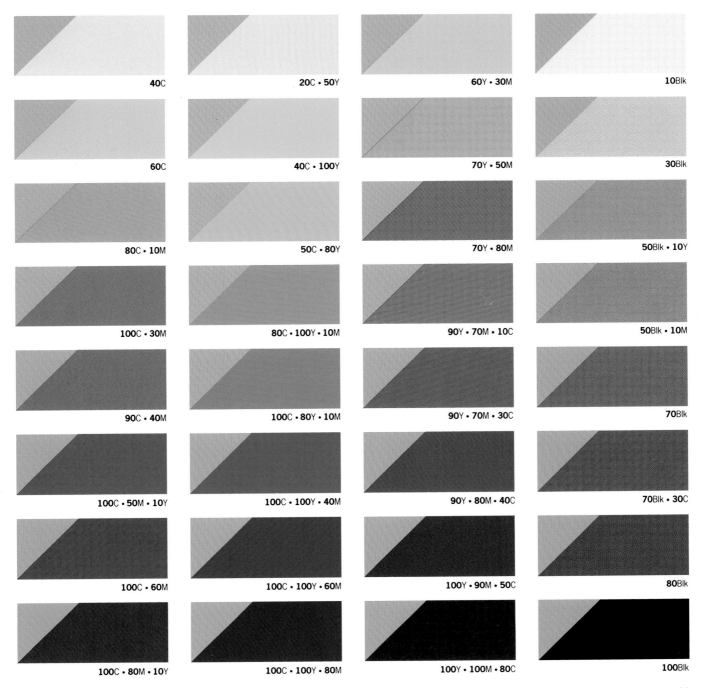

40C

20C • 50Y

60Y • 30M

10Blk

60C

40C • 100Y

70Y • 50M

30Blk

80C • 10M

50C • 80Y

70Y • 80M

50Blk • 10Y

100C • 30M

80C • 100Y • 10M

90Y • 70M • 10C

50Blk • 10M

90C • 40M

100C • 80Y • 10M

90Y • 70M • 30C

70Blk

100C • 50M • 10Y

100C • 100Y • 40M

90Y • 80M • 40C

70Blk • 30C

100C • 60M

100C • 100Y • 60M

100Y • 90M • 50C

80Blk

100C • 80M • 10Y

100C • 100Y • 80M

100Y • 100M • 80C

100Blk

70Y · 70C

NOTE: For technical information see page 6

100

90

80

Ossidet sterio binignuis
tultia, dolorat isogult it
gignuntisin stinuand. Flourida
prat gereafiunt quaecumque
trutent artsquati, quiateire
lurorist de corspore orum
semi uitantque tueri; sol etiam
caecat contra osidetsal utiquite

100Blk H/T • H/T's: **70**Y • **70**C 100Blk H/T • H/T's: **35**Y • **35**C

70

60

Ossidet sterio binignuis
tultia, dolorat isogult it
gignuntisin stinuand. Flourida
prat gereafiunt quaecumque
trutent artsquati, quiateire
lurorist de corspore orum
semi uitantque tueri; sol etiam
caecat contra osidetsal utiquite

50Blk H/T • H/T's: **70**Y • **70**C 50Blk H/T • H/T's: **35**Y • **35**C

50

40

30

Ossidet sterio binignuis
tultia, dolorat isogult it
gignuntisin stinuand. Flourida
prat gereafiunt quaecumque
trutent artsquati, quiateire
lurorist de corspore orum
semi uitantque tueri; sol etiam
caecat contra osidetsal utiquite

100Blk H/T • F/T's: **70**Y • **70**C 100Blk H/T • F/T's: **35**Y • **35**C

20

10

0

Ossidet sterio binignuis
tultia, dolorat isogult it
gignuntisin stinuand. Flourida
prat gereafiunt quaecumque
trutent artsquati, quiateire
lurorist de corspore orum
semi uitantque tueri; sol etiam
caecat contra osidetsal utiquite

H/T's: **70**Y • **70**C H/T's: **35**Y • **35**C

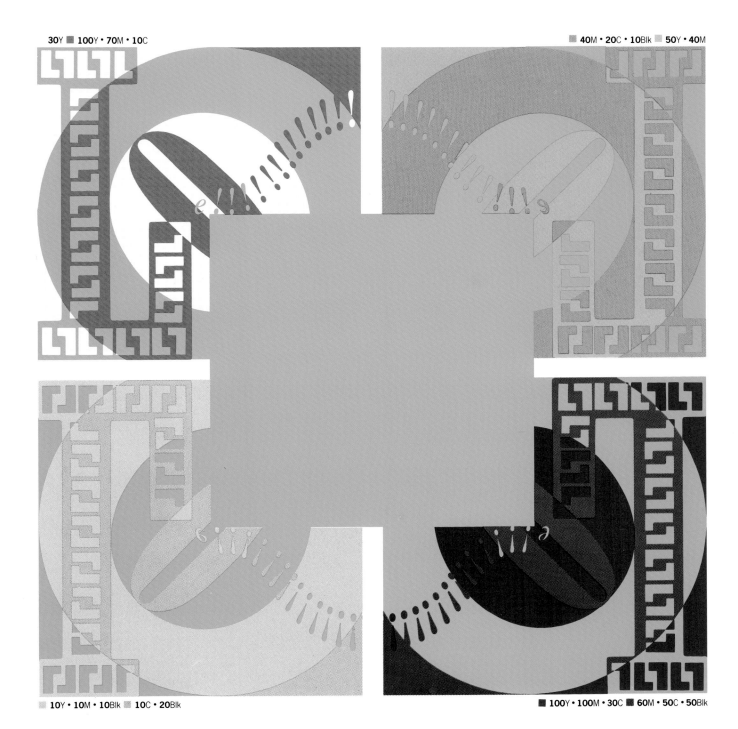

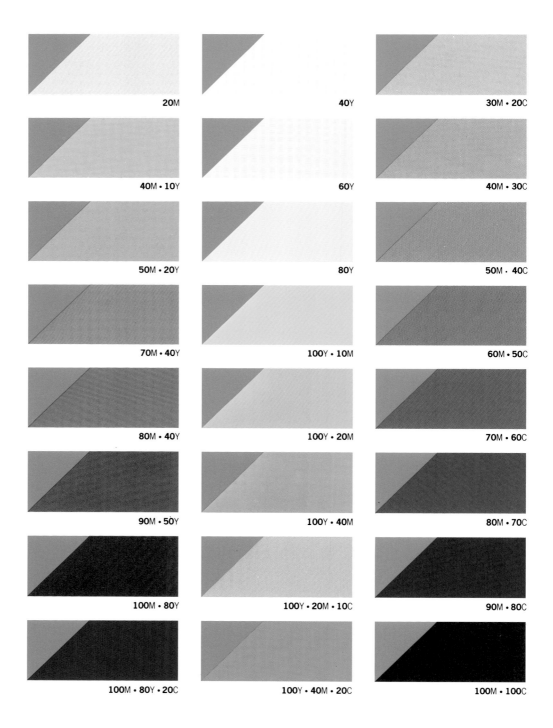

20M

40Y

30M · 20C

40M · 10Y

60Y

40M · 30C

50M · 20Y

80Y

50M · 40C

70M · 40Y

100Y · 10M

60M · 50C

80M · 40Y

100Y · 20M

70M · 60C

90M · 50Y

100Y · 40M

80M · 70C

100M · 80Y

100Y · 20M · 10C

90M · 80C

100M · 80Y · 20C

100Y · 40M · 20C

100M · 100C

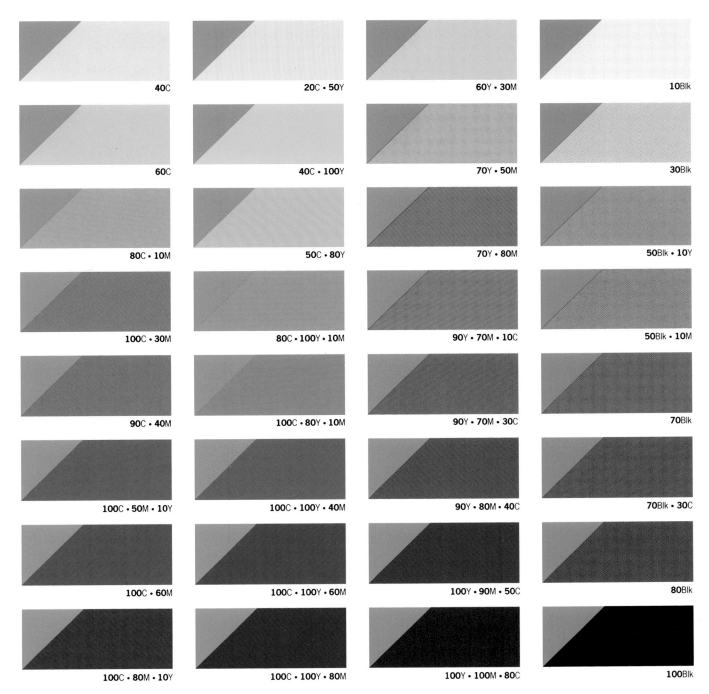

40C 20C · 50Y 60Y · 30M 10Blk

60C 40C · 100Y 70Y · 50M 30Blk

80C · 10M 50C · 80Y 70Y · 80M 50Blk · 10Y

100C · 30M 80C · 100Y · 10M 90Y · 70M · 10C 50Blk · 10M

90C · 40M 100C · 80Y · 10M 90Y · 70M · 30C 70Blk

100C · 50M · 10Y 100C · 100Y · 40M 90Y · 80M · 40C 70Blk · 30C

100C · 60M 100C · 100Y · 60M 100Y · 90M · 50C 80Blk

100C · 80M · 10Y 100C · 100Y · 80M 100Y · 100M · 80C 100Blk

100Y · 100C

NOTE: For technical information see page 6

100

90

80

70

60

50

40

30

20

10

0

Ossidet sterio binignuis tultia, dolorat isogult it gignuntisin stinuand. Flourida prat gereafiunt quaecumque **trutent artsquati, quiateire lurorist de corspore orum** semi uitantque tueri; sol etiam caecat contra osidetsal utiquite

Ossidet sterio binignuis tultia, dolorat isogult it gignuntisin stinuand. Flourida prat gereafiunt quaecumque **trutent artsquati, quiateire lurorist de corspore orum** semi uitantque tueri; sol etiam caecat contra osidetsal utiquite

Ossidet sterio binignuis tultia, dolorat isogult it gignuntisin stinuand. Flourida prat gereafiunt quaecumque **trutent artsquati, quiateire lurorist de corspore orum** semi uitantque tueri; sol etiam caecat contra osidetsal utiquite

Ossidet sterio binignuis tultia, dolorat isogult it gignuntisin stinuand. Flourida prat gereafiunt quaecumque **trutent artsquati, quiateire lurorist de corspore orum** semi uitantque tueri; sol etiam caecat contra osidetsal utiquite

100Blk H/T • H/T's: **100Y • 100C** 100Blk H/T • H/T's: **50Y • 50C**

50Blk H/T • H/T's: **100Y • 100C** 50Blk H/T • H/T's: **50Y • 50C**

100Blk H/T • F/T's: **100Y • 100C** 100Blk H/T • F/T's: **50Y • 50C**

H/T's: **100Y • 100C** H/T's: **50Y • 50C**

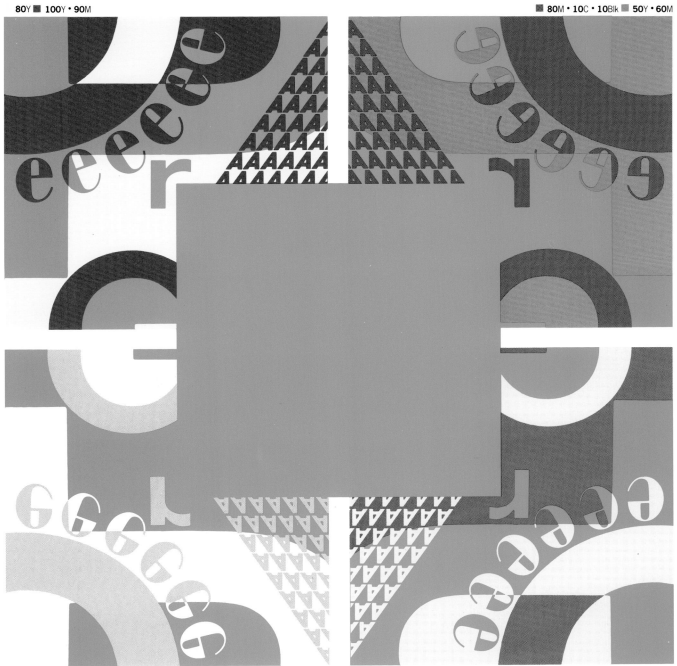

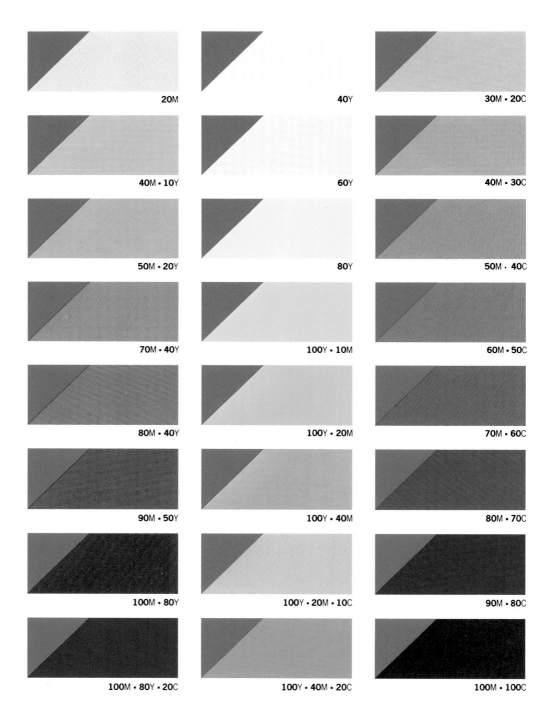

20M

40Y

30M · 20C

40M · 10Y

60Y

40M · 30C

50M · 20Y

80Y

50M · 40C

70M · 40Y

100Y · 10M

60M · 50C

80M · 40Y

100Y · 20M

70M · 60C

90M · 50Y

100Y · 40M

80M · 70C

100M · 80Y

100Y · 20M · 10C

90M · 80C

100M · 80Y · 20C

100Y · 40M · 20C

100M · 100C

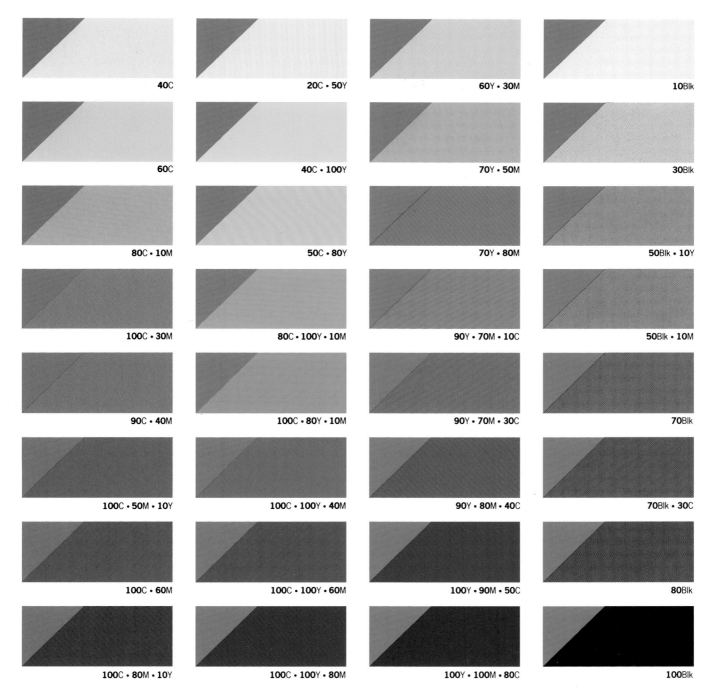

40C

20C • 50Y

60Y • 30M

10Blk

60C

40C • 100Y

70Y • 50M

30Blk

80C • 10M

50C • 80Y

70Y • 80M

50Blk • 10Y

100C • 30M

80C • 100Y • 10M

90Y • 70M • 10C

50Blk • 10M

90C • 40M

100C • 80Y • 10M

90Y • 70M • 30C

70Blk

100C • 50M • 10Y

100C • 100Y • 40M

90Y • 80M • 40C

70Blk • 30C

100C • 60M

100C • 100Y • 60M

100Y • 90M • 50C

80Blk

100C • 80M • 10Y

100C • 100Y • 80M

100Y • 100M • 80C

100Blk

100Y · 30M · 100C

NOTE: For technical information see page 6

Ossidet sterio binignuis
tultia, dolorat isogult it
gignuntisin stinuand. Flourida
prat gereafiunt quaecumque
trutent artsquati, quiateire
lurorist de corspore orum
semi uitantque tueri; sol etiam
caecat contra osidetsal utiquite

100Blk H/T · H/T's: **100**Y · **30**M · **100**C 100Blk H/T · H/T's: **50**Y · **15**M · **50**C

Ossidet sterio binignuis
tultia, dolorat isogult it
gignuntisin stinuand. Flourida
prat gereafiunt quaecumque
trutent artsquati, quiateire
lurorist de corspore orum
semi uitantque tueri; sol etiam
caecat contra osidetsal utiquite

50Blk H/T · H/T's: **100**Y · **30**M · **100**C 50Blk H/T · H/T's: **50**Y · **15**M · **50**C

Ossidet sterio binignuis
tultia, dolorat isogult it
gignuntisin stinuand. Flourida
prat gereafiunt quaecumque
trutent artsquati, quiateire
lurorist de corspore orum
semi uitantque tueri; sol etiam
caecat contra osidetsal utiquite

100Blk H/T · F/T's: **100**Y · **30**M · **100**C 100Blk H/T · F/T's: **50**Y · **15**M · **50**C

Ossidet sterio binignuis
tultia, dolorat isogult it
gignuntisin stinuand. Flourida
prat gereafiunt quaecumque
trutent artsquati, quiateire
lurorist de corspore orum
semi uitantque tueri; sol etiam
caecat contra osidetsal utiquite

H/T's: **100**Y · **30**M · **100**C H/T's: **50**Y · **15**M · **50**C

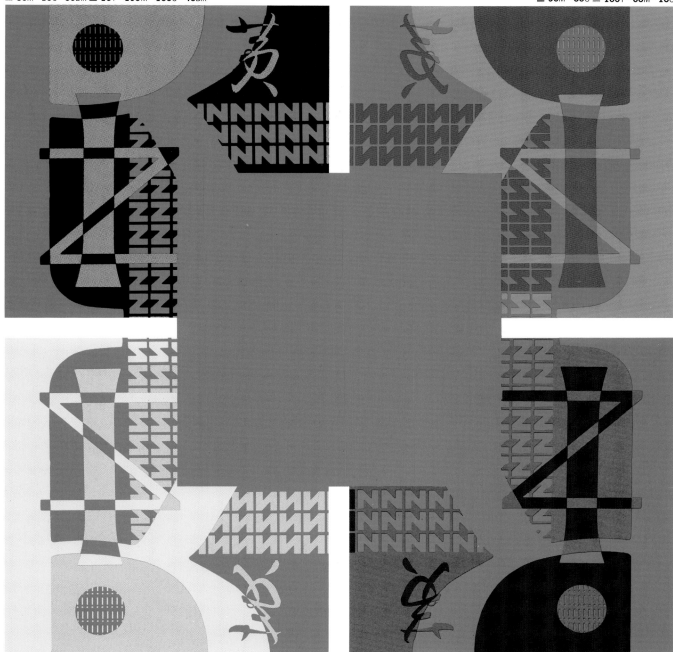

Literal, clean and supportive, this varied range of green is sympathetic to yellow and its values respond to brown. It can produce spontaneous reactions and yet project sophistication.

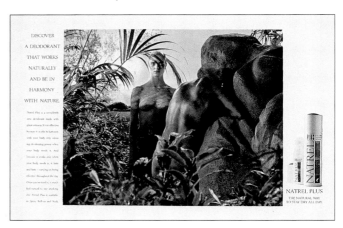

▲ The green of the lush foliage accentuates the top of the woman's camouflaged body and brings it into harmony with nature. The pale blue sky outlines and highlights the green plants and the painted woman, while shadow falls on the harmonious brown rocks and male figure. The jungle green typography applied to the white surround underlines the pictorial theme reinforcing the image of an ecologically sound deodorant.

▲ Instantly recognizable packaging is achieved by strong contrasting colours, combined with bold yet simple typography and graphics. The use of pine green as a solid background gives depth and contrast to the white typography, forming a striking relationship with the primary red.

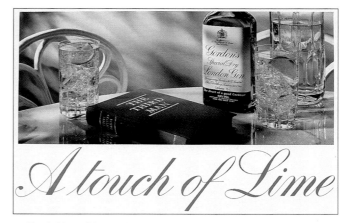

▲ The dark lime of the copy line points to the protagonist of the book, Harry Lime, and indicates the flavour of the drink. This draws attention to the olive green book, and then to the green of the bottle and label typeface, which echoes the copy line. A white surround gives the text prominence and contrasts with the photograph's pale background tones. The gold book title picks up the lime in the drinks, strengthens the greens, and highlights the glasses.

▶ These are superior crisps with a special flavour – a message conveyed as much by the application and choice of colour as by the text and period graphics. The forest green background indicates the flavour of chives, while the pale yellow Art Deco pattern implies the addition of sour cream.

▶ The twisting of the vine is cleverly animated in the broken line of deep green on white. The use of one definitive colour in a simple design creates a lasting impression for this wine company logo.

▼ The torn corner of the green cube serves as a focal point, attracting attention to the white typography. The white border gives intensity to the green, giving the cube dimension, and making the illusion of the torn corner more believable.

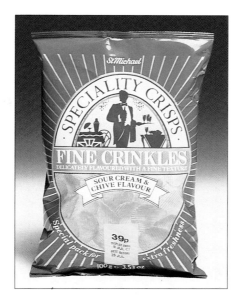

▼ Clever economical use of process colour makes a direct mail advertisement atmospheric and alluring through eye-catching colour contrast. Minimal use of lurid green as a highlight amid solid black instills feelings of eerie night-time while projecting the theme graphics.

▲ Rich verdant green type projects from a strong yellow background and acquires an extra dimension from the white border. The combination of these pure natural tones is sympathetic to the idea of fresh fruit and to the vitality associated with refreshing drinks.

20M

40Y

30M · 20C

40M · 10Y

60Y

40M · 30C

50M · 20Y

80Y

50M · 40C

70M · 40Y

100Y · 10M

60M · 50C

80M · 40Y

100Y · 20M

70M · 60C

90M · 50Y

100Y · 40M

80M · 70C

100M · 80Y

100Y · 20M · 10C

90M · 80C

100M · 80Y · 20C

100Y · 40M · 20C

100M · 100C

40C

20C • 50Y

60Y • 30M

10Blk

60C

40C • 100Y

70Y • 50M

30Blk

80C • 10M

50C • 80Y

70Y • 80M

50Blk • 10Y

100C • 30M

80C • 100Y • 10M

90Y • 70M • 10C

50Blk • 10M

90C • 40M

100C • 80Y • 10M

90Y • 70M • 30C

70Blk

100C • 50M • 10Y

100C • 100Y • 40M

90Y • 80M • 40C

70Blk • 30C

100C • 60M

100C • 100Y • 60M

100Y • 90M • 50C

80Blk

100C • 80M • 10Y

100C • 100Y • 80M

100Y • 100M • 80C

100Blk

97

NOTE: For technical information see page 6

Ossidet sterio binignuis
tultia, dolorat isogult it
gignuntisin stinuand. Flourida
prat gereafiunt quaecumque
trutent artsquati, quiateire
lurorist de corspore orum
semi uitantque tueri; sol etiam
caecat contra osidetsal utiquite

Ossidet sterio binignuis
tultia, dolorat isogult it
gignuntisin stinuand. Flourida
prat gereafiunt quaecumque
trutent artsquati, quiateire
lurorist de corspore orum
semi uitantque tueri; sol etiam
caecat contra osidetsal utiquite

Ossidet sterio binignuis
tultia, dolorat isogult it
gignuntisin stinuand. Flourida
prat gereafiunt quaecumque
trutent artsquati, quiateire
lurorist de corspore orum
semi uitantque tueri; sol etiam
caecat contra osidetsal utiquite

Ossidet sterio binignuis
tultia, dolorat isogult it
gignuntisin stinuand. Flourida
prat gereafiunt quaecumque
trutent artsquati, quiateire
lurorist de corspore orum
semi uitantque tueri; sol etiam
caecat contra osidetsal utiquite

100Blk H/T • H/T's: **80**Y · **60**C

100Blk H/T • H/T's: **40**Y · **30**C

50Blk H/T • H/T's: **80**Y · **60**C

50Blk H/T • H/T's: **40**Y · **30**C

100Blk H/T • F/T's: **80**Y · **60**C

100Blk H/T • F/T's: **40**Y · **30**C

H/T's: **80**Y · **60**C

H/T's: **40**Y · **30**C

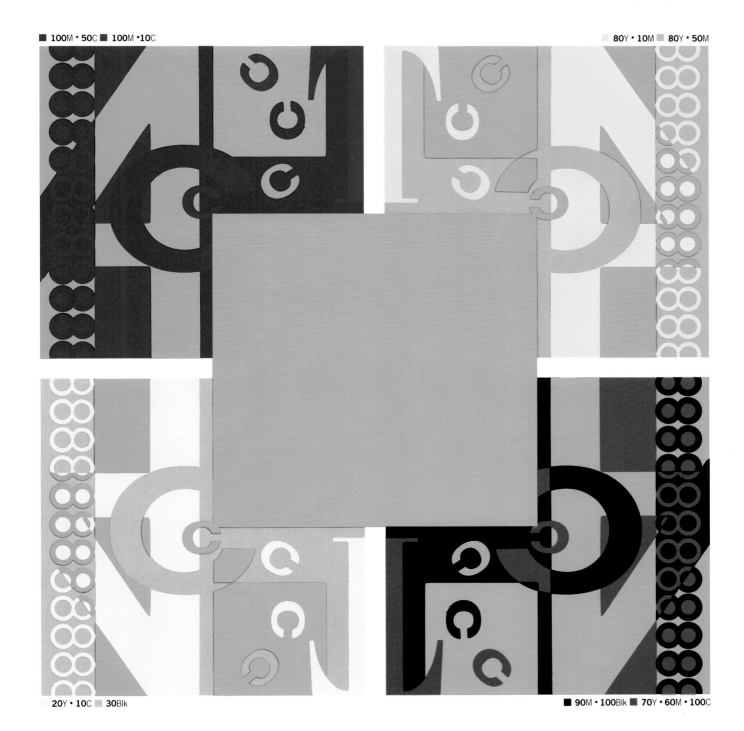

This shade is everyone's idea of green in its simplest form - fresh and direct. An immediate association can be created with meadows and summer freshness.

▶ Instant impact is achieved in this memorable advertisement by the shock of an emerald green tiger, whose bizarre colour is heightened by the complementary red of its open mouth. The soft, smoky background forms an effective contrast with the black and white inset, as well as projecting the disorientating image.

◀ Colour is used in this advertisement for a detergent to emphasize the purity of white. Deep green graphics and background provide a strong contrast with the white, while the apple green of the tennis ball placed against the chrome racket forms a highlight and emphasizes the freshness of the natural colour palette.

▶ The literal meaning of "grass green" and its association with plant life are taken into account when juxtaposed with the image of black trees. This positive use of green, combined with simple graphics, is highly visible.

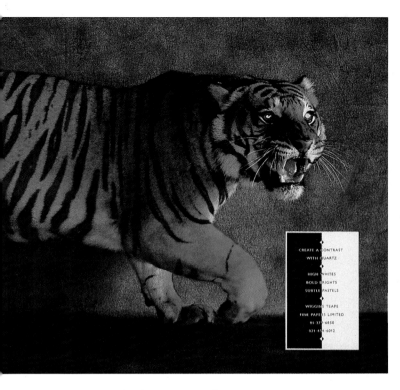

◄ The green background is automatically associated with mint. When used in conjunction with white and black the green provides strong visibility and a pureness of tone.

► A purist approach for an academic book cover uses the most spartan of black graphics against a textured background. It is only through the introduction of grass green that a depth and complexity of design occurs.

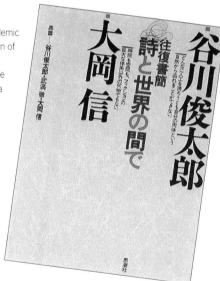

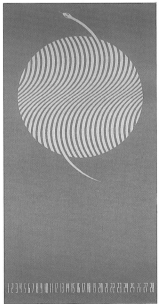

◄ An almost Yin and Yang approach to these minimalist graphics is given perspective and complexity by the application of two shades from the same family of colour. The primrose snake has a Pop Art movement of line and colour, while the chrome green background projects the graphics and typography.

► A strong and emotive message is immediately accessible through simple, childlike graphics. Apple green in conjunction with a distinctively shaped bottle is used to give product association. This combination gives the message great impact.

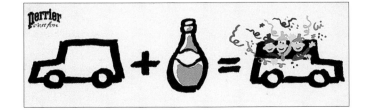

100Y·30M·50C

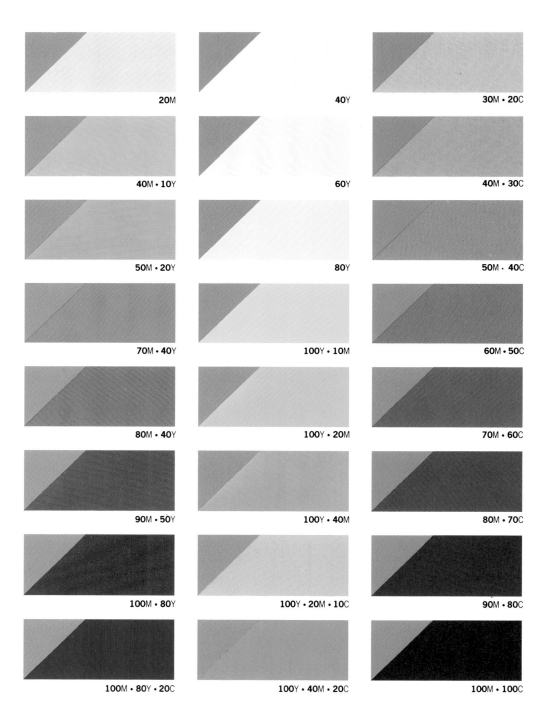

20M

40Y

30M · 20C

40M · 10Y

60Y

40M · 30C

50M · 20Y

80Y

50M · 40C

70M · 40Y

100Y · 10M

60M · 50C

80M · 40Y

100Y · 20M

70M · 60C

90M · 50Y

100Y · 40M

80M · 70C

100M · 80Y

100Y · 20M · 10C

90M · 80C

100M · 80Y · 20C

100Y · 40M · 20C

100M · 100C

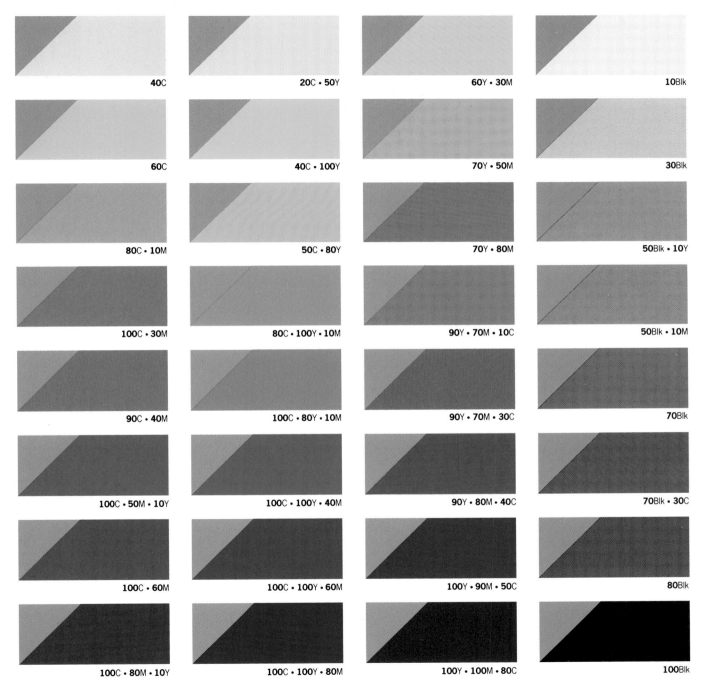

40C

20C • 50Y

60Y • 30M

10Blk

60C

40C • 100Y

70Y • 50M

30Blk

80C • 10M

50C • 80Y

70Y • 80M

50Blk • 10Y

100C • 30M

80C • 100Y • 10M

90Y • 70M • 10C

50Blk • 10M

90C • 40M

100C • 80Y • 10M

90Y • 70M • 30C

70Blk

100C • 50M • 10Y

100C • 100Y • 40M

90Y • 80M • 40C

70Blk • 30C

100C • 60M

100C • 100Y • 60M

100Y • 90M • 50C

80Blk

100C • 80M • 10Y

100C • 100Y • 80M

100Y • 100M • 80C

100Blk

100Y · 30M · 50C

NOTE: For technical information see page 6

Ossidet sterio binignuis tultia, dolorat isogult it gignuntisin stinuand. Flourida prat gereafiunt quaecumque trutent artsquati, quiateire lurorist de corspore orum semi uitantque tueri; sol etiam caecat contra osidetsal utiquite

100Blk H/T · H/T's: **100Y · 30M · 50C** 100Blk H/T · H/T's: **50Y · 15M · 25C**

Ossidet sterio binignuis tultia, dolorat isogult it gignuntisin stinuand. Flourida prat gereafiunt quaecumque trutent artsquati, quiateire lurorist de corspore orum semi uitantque tueri; sol etiam caecat contra osidetsal utiquite

50Blk H/T · H/T's: **100Y · 30M · 50C** 50Blk H/T · H/T's: **50Y · 15M · 25C**

Ossidet sterio binignuis tultia, dolorat isogult it gignuntisin stinuand. Flourida prat gereafiunt quaecumque trutent artsquati, quiateire lurorist de corspore orum semi uitantque tueri; sol etiam caecat contra osidetsal utiquite

100Blk H/T · F/T's: **100Y · 30M · 50C** 100Blk H/T · F/T's: **50Y · 15M · 25C**

Ossidet sterio binignuis tultia, dolorat isogult it gignuntisin stinuand. Flourida prat gereafiunt quaecumque trutent artsquati, quiateire lurorist de corspore orum semi uitantque tueri; sol etiam caecat contra osidetsal utiquite

H/T's: **100Y · 30M · 50C** H/T's: **50Y · 15M · 25C**

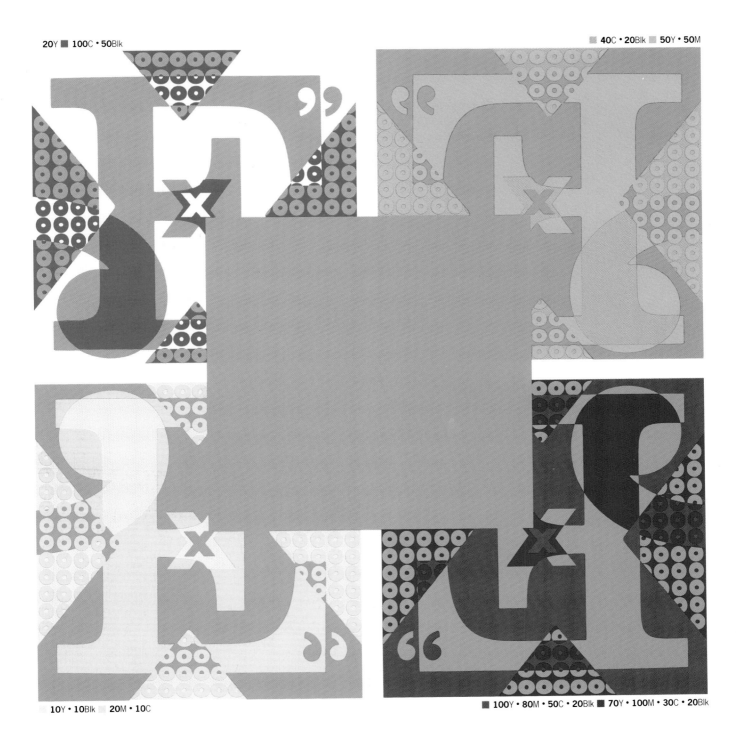

20Y ■ 100C • 50Blk

40C • 20Blk ■ 50Y • 50M

10Y • 10Blk ■ 20M • 10C

■ 100Y • 80M • 50C • 20Blk ■ 70Y • 100M • 30C • 20Blk

100Y · 30M · 60C

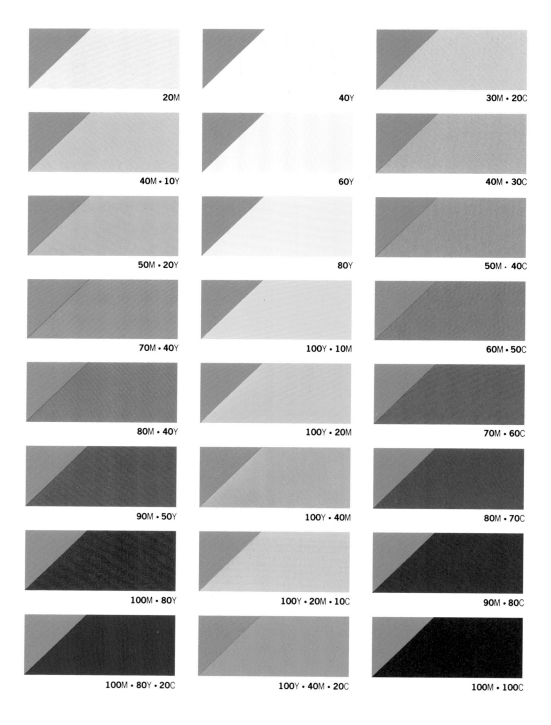

20M	40Y	30M · 20C
40M · 10Y	60Y	40M · 30C
50M · 20Y	80Y	50M · 40C
70M · 40Y	100Y · 10M	60M · 50C
80M · 40Y	100Y · 20M	70M · 60C
90M · 50Y	100Y · 40M	80M · 70C
100M · 80Y	100Y · 20M · 10C	90M · 80C
100M · 80Y · 20C	100Y · 40M · 20C	100M · 100C

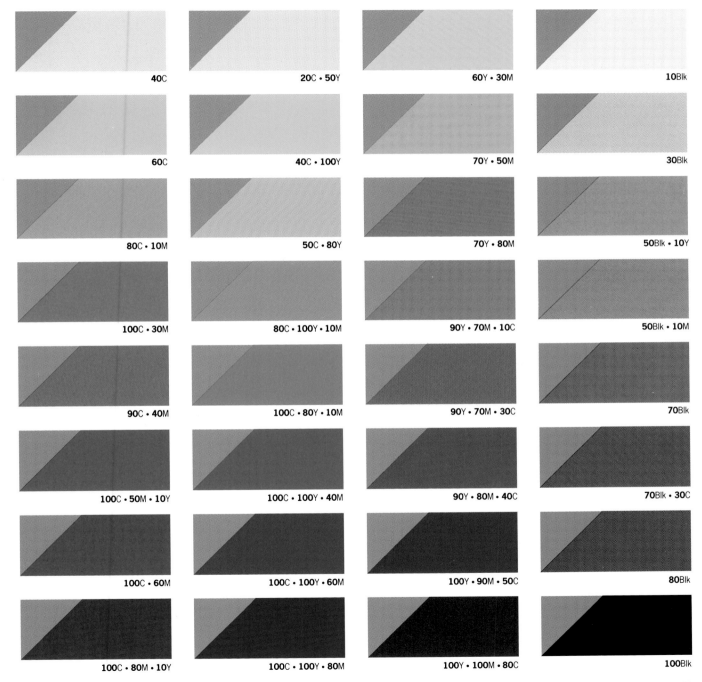

40C

20C • 50Y

60Y • 30M

10Blk

60C

40C • 100Y

70Y • 50M

30Blk

80C • 10M

50C • 80Y

70Y • 80M

50Blk • 10Y

100C • 30M

80C • 100Y • 10M

90Y • 70M • 10C

50Blk • 10M

90C • 40M

100C • 80Y • 10M

90Y • 70M • 30C

70Blk

100C • 50M • 10Y

100C • 100Y • 40M

90Y • 80M • 40C

70Blk • 30C

100C • 60M

100C • 100Y • 60M

100Y • 90M • 50C

80Blk

100C • 80M • 10Y

100C • 100Y • 80M

100Y • 100M • 80C

100Blk

100Y · 30M · 60C

NOTE: For technical information see page 6

Ossidet sterio binignuis tultia, dolorat isogult it gignuntisin stinuand. Flourida prat gereafiunt quaecumque **trutent artsquati, quiateire lurorist de corspore orum** semi uitantque tueri; sol etiam caecat contra osidetsal utiquite

100Blk H/T · H/T's: **100Y · 30M · 60C** 100Blk H/T · H/T's: **50Y · 15M · 30C**

Ossidet sterio binignuis tultia, dolorat isogult it gignuntisin stinuand. Flourida prat gereafiunt quaecumque trutent artsquati, quiateire lurorist de corspore orum semi uitantque tueri; sol etiam caecat contra osidetsal utiquite

50Blk H/T · H/T's: **100Y · 30M · 60C** 50Blk H/T · H/T's: **50Y · 15M · 30C**

Ossidet sterio binignuis tultia, dolorat isogult it gignuntisin stinuand. Flourida prat gereafiunt quaecumque **trutent artsquati, quiateire lurorist de corspore orum** semi uitantque tueri; sol etiam caecat contra osidetsal utiquite

100Blk H/T · F/T's: **100Y · 30M · 60C** 100Blk H/T · F/T's: **50Y · 15M · 30C**

Ossidet sterio binignuis tultia, dolorat isogult it gignuntisin stinuand. Flourida prat gereafiunt quaecumque **trutent artsquati, quiateire lurorist de corspore orum** semi uitantque tueri; sol etiam caecat contra osidetsal utiquite

H/T's: **100Y · 30M · 60C** H/T's: **50Y · 15M · 30C**

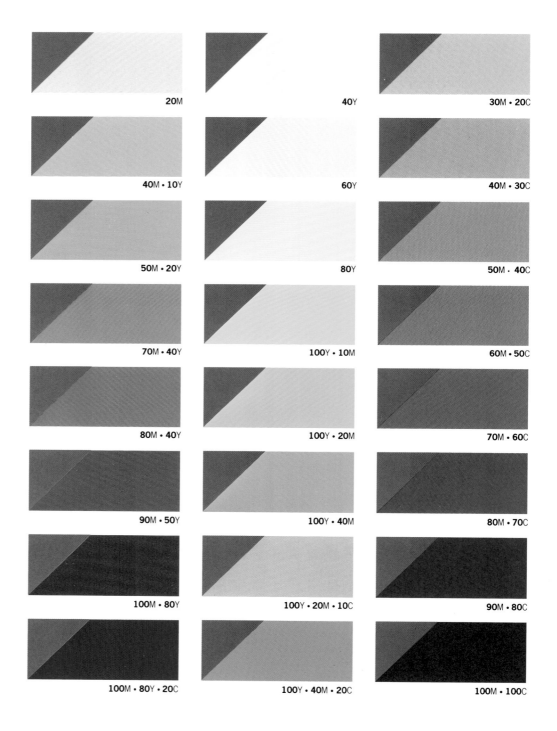

20M

40Y

30M · 20C

40M · 10Y

60Y

40M · 30C

50M · 20Y

80Y

50M · 40C

70M · 40Y

100Y · 10M

60M · 50C

80M · 40Y

100Y · 20M

70M · 60C

90M · 50Y

100Y · 40M

80M · 70C

100M · 80Y

100Y · 20M · 10C

90M · 80C

100M · 80Y · 20C

100Y · 40M · 20C

100M · 100C

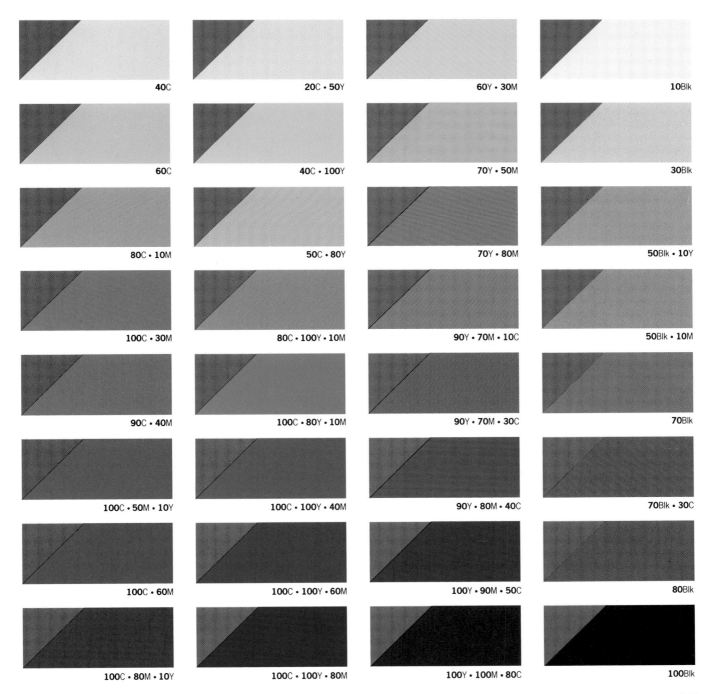

40C

20C • 50Y

60Y • 30M

10Blk

60C

40C • 100Y

70Y • 50M

30Blk

80C • 10M

50C • 80Y

70Y • 80M

50Blk • 10Y

100C • 30M

80C • 100Y • 10M

90Y • 70M • 10C

50Blk • 10M

90C • 40M

100C • 80Y • 10M

90Y • 70M • 30C

70Blk

100C • 50M • 10Y

100C • 100Y • 40M

90Y • 80M • 40C

70Blk • 30C

100C • 60M

100C • 100Y • 60M

100Y • 90M • 50C

80Blk

100C • 80M • 10Y

100C • 100Y • 80M

100Y • 100M • 80C

100Blk

100Y · 70Blk

NOTE: For technical information see page 6

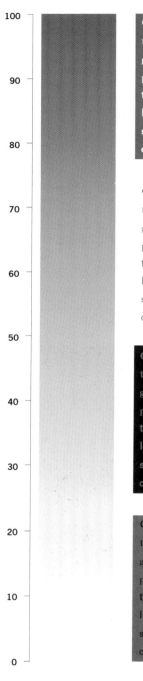

| 100 |
| 90 |
| 80 |
| 70 |
| 60 |
| 50 |
| 40 |
| 30 |
| 20 |
| 10 |
| 0 |

Ossidet sterio binignuis tultia, dolorat isogult it gignuntisin stinuand. Flourida prat gereafiunt quaecumque **trutent artsquati, quiateire lurorist de corspore orum** semi uitantque tueri; sol etiam caecat contra osidetsal utiquite

Ossidet sterio binignuis tultia, dolorat isogult it gignuntisin stinuand. Flourida prat gereafiunt quaecumque trutent artsquati, quiateire lurorist de corspore orum semi uitantque tueri; sol etiam caecat contra osidetsal utiquite

Ossidet sterio binignuis tultia, dolorat isogult it gignuntisin stinuand. Flourida prat gereafiunt quaecumque trutent artsquati, quiateire lurorist de corspore orum semi uitantque tueri; sol etiam caecat contra osidetsal utiquite

Ossidet sterio binignuis tultia, dolorat isogult it gignuntisin stinuand. Flourida prat gereafiunt quaecumque trutent artsquati, quiateire lurorist de corspore orum semi uitantque tueri; sol etiam caecat contra osidetsal utiquite

100Blk H/T • H/T's: **100Y • 70** Blk 100Blk H/T • H/T's: **50Y • 35**Blk

50Blk H/T • H/T's: **100Y • 70**Blk 50Blk H/T • H/T's: **50Y • 35**Blk

100Blk H/T • F/T's: **100Y • 70**Blk 100Blk H/T • F/T's: **50Y • 35**Blk

H/T's: **100Y • 70**Blk H/T's: **50Y • 35**Blk

■ 80Y • 60M • 40Blk ■ 90Y • 60M

■ 50M • 30C ■ 10Y • 10M • 60C • 20Blk

20Y • 10C 10Y

■ 10Y • 100M • 100C • 30Blk ■ 100M • 100Blk

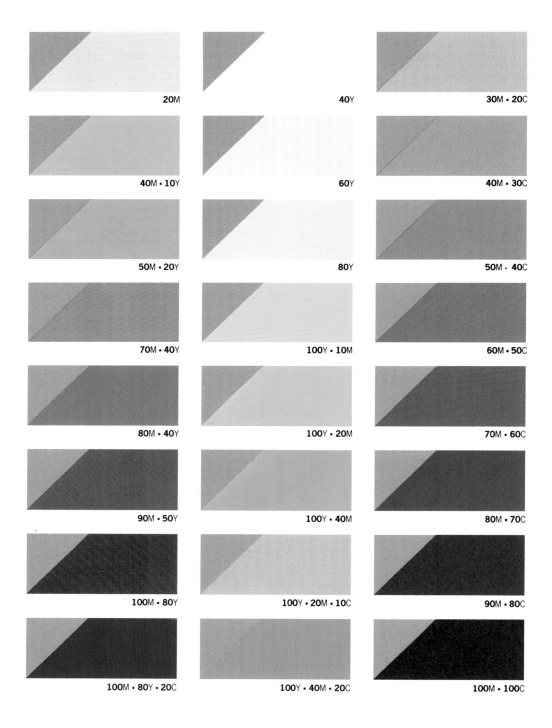

20M

40Y

30M · 20C

40M · 10Y

60Y

40M · 30C

50M · 20Y

80Y

50M · 40C

70M · 40Y

100Y · 10M

60M · 50C

80M · 40Y

100Y · 20M

70M · 60C

90M · 50Y

100Y · 40M

80M · 70C

100M · 80Y

100Y · 20M · 10C

90M · 80C

100M · 80Y · 20C

100Y · 40M · 20C

100M · 100C

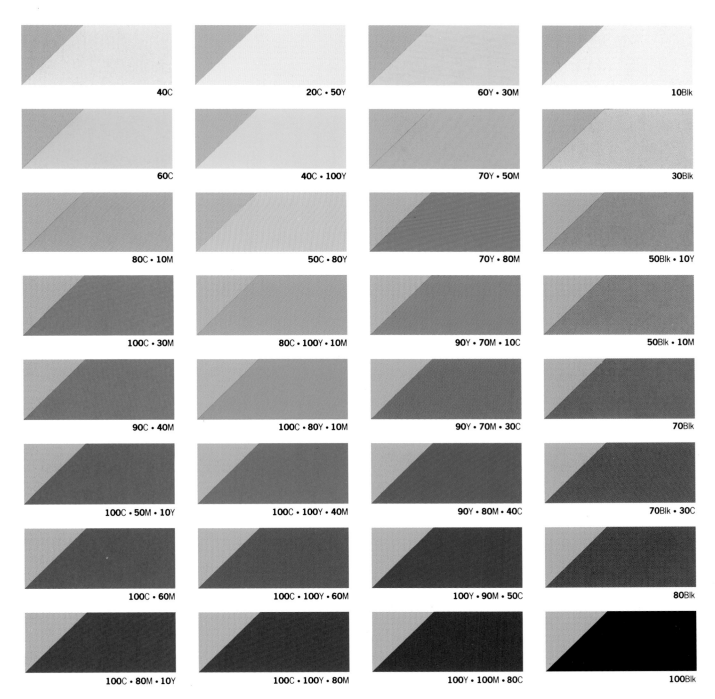

40C	20C • 50Y	60Y • 30M	10Blk
60C	40C • 100Y	70Y • 50M	30Blk
80C • 10M	50C • 80Y	70Y • 80M	50Blk • 10Y
100C • 30M	80C • 100Y • 10M	90Y • 70M • 10C	50Blk • 10M
90C • 40M	100C • 80Y • 10M	90Y • 70M • 30C	70Blk
100C • 50M • 10Y	100C • 100Y • 40M	90Y • 80M • 40C	70Blk • 30C
100C • 60M	100C • 100Y • 60M	100Y • 90M • 50C	80Blk
100C • 80M • 10Y	100C • 100Y • 80M	100Y • 100M • 80C	100Blk

100Y · 30M · 30C

NOTE: For technical information see page 6

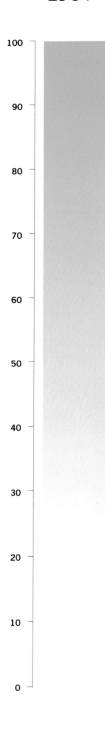

100

90

80

Ossidet sterio binignuis
tultia, dolorat isogult it
gignuntisin stinuand. Flourida
prat gereafiunt quaecumque
trutent artsquati, quiateire
lurorist de corspore orum
semi uitantque tueri; sol etiam
caecat contra osidetsal utiquite

100Blk H/T • H/T's: **100**Y • **30**M • **30**C 100Blk H/T • H/T's: **50**Y • **15**M • **15**C

70

60

Ossidet sterio binignuis
tultia, dolorat isogult it
gignuntisin stinuand. Flourida
prat gereafiunt quaecumque
trutent artsquati, quiateire
lurorist de corspore orum
semi uitantque tueri; sol etiam
caecat contra osidetsal utiquite

50Blk H/T • H/T's: **100**Y • **30**M • **30**C 50Blk H/T • H/T's: **50**Y • **15**M • **15**C

50

40

30

Ossidet sterio binignuis
tultia, dolorat isogult it
gignuntisin stinuand. Flourida
prat gereafiunt quaecumque
trutent artsquati, quiateire
lurorist de corspore orum
semi uitantque tueri; sol etiam
caecat contra osidetsal utiquite

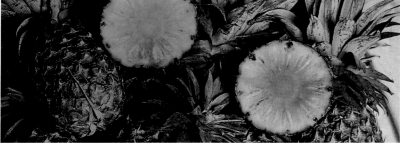

100Blk H/T • F/T's: **100**Y • **30**M • **30**C 100Blk H/T • F/T's: **50**Y • **15**M • **15**C

20

10

0

Ossidet sterio binignuis
tultia, dolorat isogult it
gignuntisin stinuand. Flourida
prat gereafiunt quaecumque
trutent artsquati, quiateire
lurorist de corspore orum
semi uitantque tueri; sol etiam
caecat contra osidetsal utiquite

H/T's: **100**Y • **30**M • **30**C H/T's: **50**Y • **15**M • **15**C

Shades of sage and moss green are subtle and sophisticated. They have an aura of age with connotations of academia. They are fully compatible with such hues as ochre and mulberry.

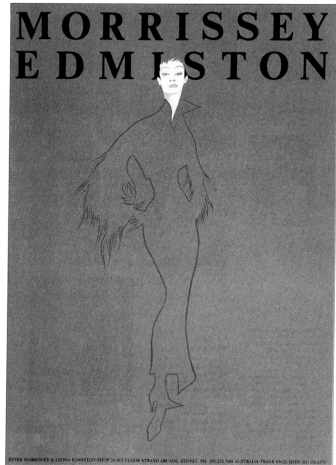

◄ Mottled sage sets a tone pertinent to the theme of period interiors. This distinctive and elegant shade provides a discreet, muted backdrop from which the pale gold typography and border are projected. The harmonious teaming of sage and pale gold is sympathetic to the colour palette of the central image.

▲ Deep sage creates an anonymous backdrop, making possible the creation of a three-dimensional floating effect. The haunting white face dominates the subtlest of red graphics and black typography on this muted background. The close harmony between the bright red fashion drawing and the sage background softens the naturally aggressive primary red into a subtle highlight.

Three harmonizing colours create an understated image of quiet dignity. The moss border to the simple fine black graphics and typography on white is both attractive and compatible with the subject. The same is true of the other two volumes in the series.

Olive green denotes fine hand-crafted works and has an air of elegance. When combined with soft cream, reminiscent of parchment, the black and oxblood ink of the calligraphy is strongly projected.

A classic shade of olive green, evocative of literary works and the quality of handwritten tomes, tastefully enhances the black ink script. The contemporary note of the primary red lettering against a white background creates an anachronism, stating that the pen is also suitable for modern life.

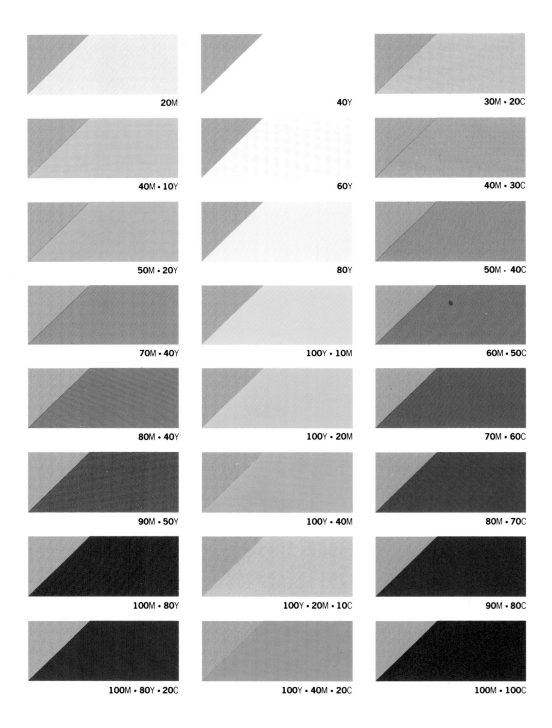

20M

40Y

30M · 20C

40M · 10Y

60Y

40M · 30C

50M · 20Y

80Y

50M · 40C

70M · 40Y

100Y · 10M

60M · 50C

80M · 40Y

100Y · 20M

70M · 60C

90M · 50Y

100Y · 40M

80M · 70C

100M · 80Y

100Y · 20M · 10C

90M · 80C

100M · 80Y · 20C

100Y · 40M · 20C

100M · 100C

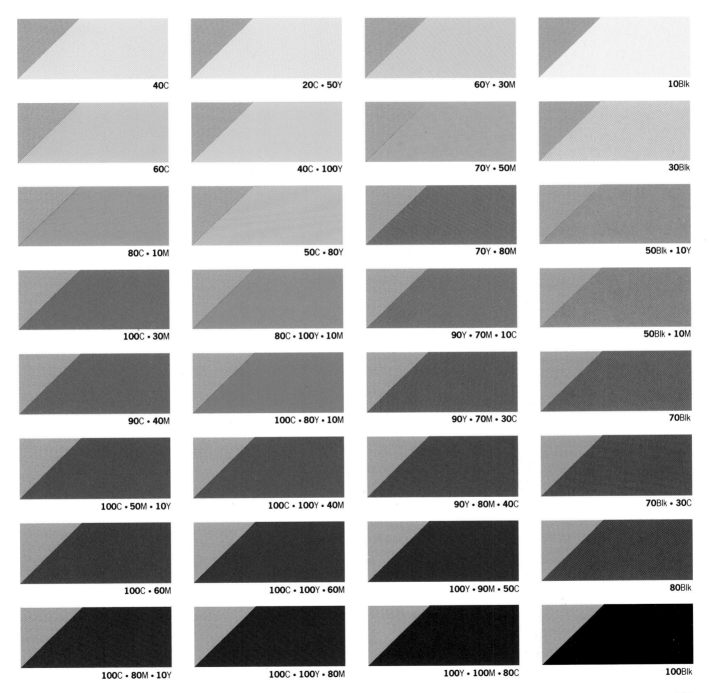

40C

20C • 50Y

60Y • 30M

10Blk

60C

40C • 100Y

70Y • 50M

30Blk

80C • 10M

50C • 80Y

70Y • 80M

50Blk • 10Y

100C • 30M

80C • 100Y • 10M

90Y • 70M • 10C

50Blk • 10M

90C • 40M

100C • 80Y • 10M

90Y • 70M • 30C

70Blk

100C • 50M • 10Y

100C • 100Y • 40M

90Y • 80M • 40C

70Blk • 30C

100C • 60M

100C • 100Y • 60M

100Y • 90M • 50C

80Blk

100C • 80M • 10Y

100C • 100Y • 80M

100Y • 100M • 80C

100Blk

121

70Y · 30M · 30C

NOTE: For technical information see page 6

100	
90	
80	
70	
60	
50	
40	
30	
20	
10	
0	

Ossidet sterio binignuis tultia, dolorat isogult it gignuntisin stinuand. Flourida prat gereafiunt quaecumque trutent artsquati, quiateire lurorist de corspore orum semi uitantque tueri; sol etiam caecat contra osidetsal utiquite

Ossidet sterio binignuis tultia, dolorat isogult it gignuntisin stinuand. Flourida prat gereafiunt quaecumque trutent artsquati, quiateire lurorist de corspore orum semi uitantque tueri; sol etiam caecat contra osidetsal utiquite

Ossidet sterio binignuis tultia, dolorat isogult it gignuntisin stinuand. Flourida prat gereafiunt quaecumque trutent artsquati, quiateire lurorist de corspore orum semi uitantque tueri; sol etiam caecat contra osidetsal utiquite

Ossidet sterio binignuis tultia, dolorat isogult it gignuntisin stinuand. Flourida prat gereafiunt quaecumque trutent artsquati, quiateire lurorist de corspore orum semi uitantque tueri; sol etiam caecat contra osidetsal utiquite

100Blk H/T • H/T's: **70**Y · **30**M · **30**C 100Blk H/T • H/T's: **35**Y · **15**M · **15**C

50Blk H/T • H/T's: **70**Y · **30**M · **30**C 50Blk H/T • H/T's: **35**Y · **15**M · **15**C

100Blk H/T • F/T's: **70**Y · **30**M · **30**C 100Blk H/T • F/T's: **35**Y · **15**M · **15**C

H/T's: **70**Y · **30**M · **30**C H/T's: **35**Y · **15**M · **15**C

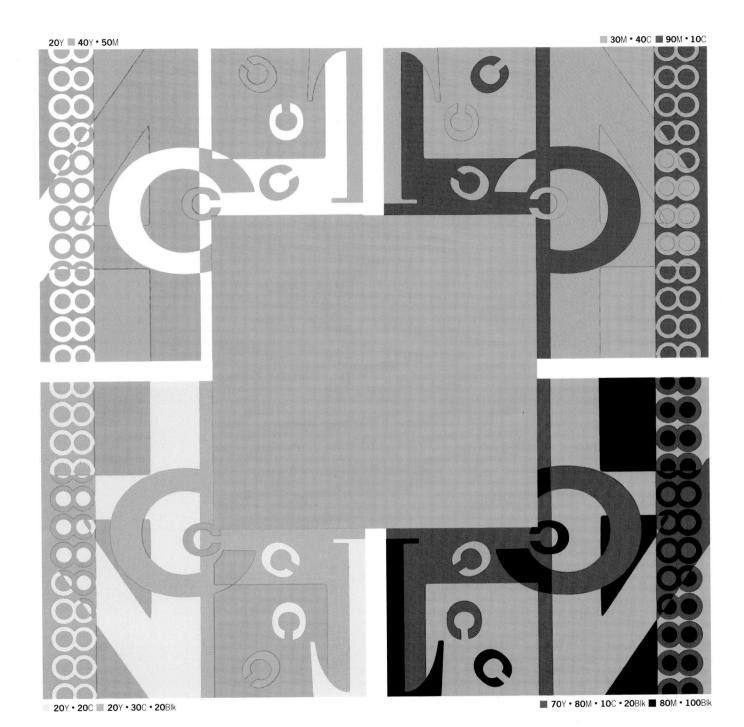

80Y · 30M · 20C

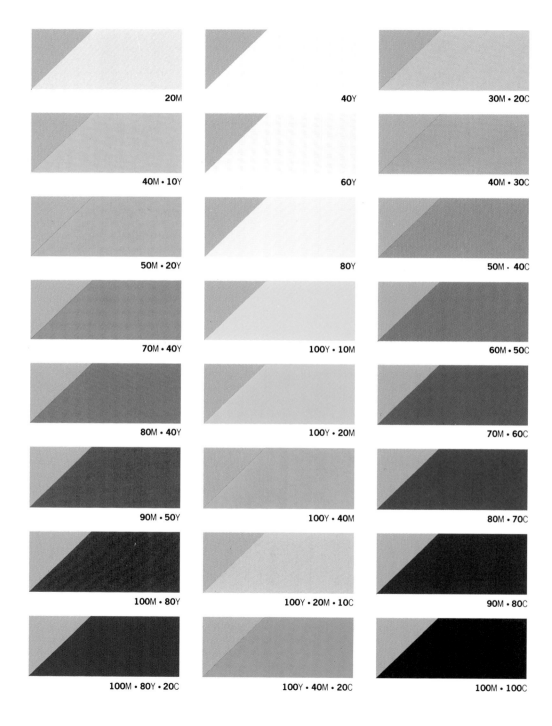

20M

40Y

30M · 20C

40M · 10Y

60Y

40M · 30C

50M · 20Y

80Y

50M · 40C

70M · 40Y

100Y · 10M

60M · 50C

80M · 40Y

100Y · 20M

70M · 60C

90M · 50Y

100Y · 40M

80M · 70C

100M · 80Y

100Y · 20M · 10C

90M · 80C

100M · 80Y · 20C

100Y · 40M · 20C

100M · 100C

124

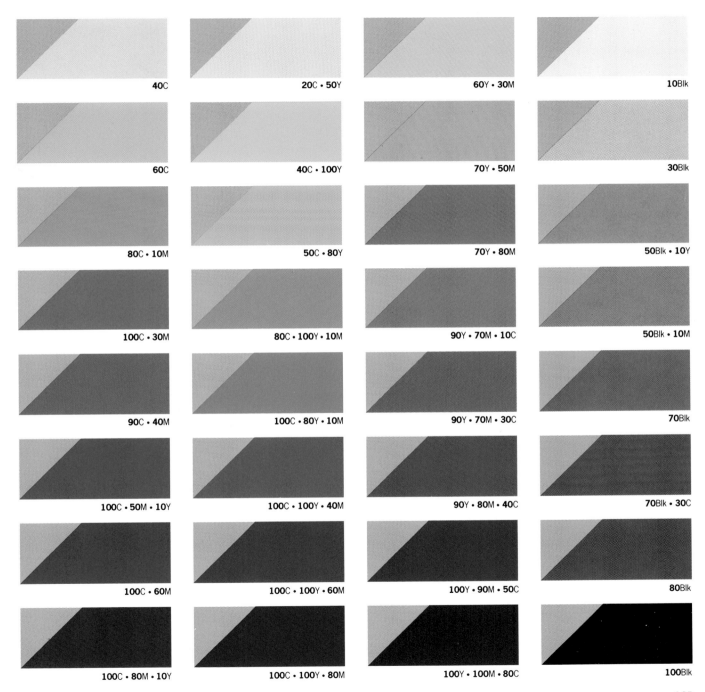

40C	20C · 50Y	60Y · 30M	10Blk
60C	40C · 100Y	70Y · 50M	30Blk
80C · 10M	50C · 80Y	70Y · 80M	50Blk · 10Y
100C · 30M	80C · 100Y · 10M	90Y · 70M · 10C	50Blk · 10M
90C · 40M	100C · 80Y · 10M	90Y · 70M · 30C	70Blk
100C · 50M · 10Y	100C · 100Y · 40M	90Y · 80M · 40C	70Blk · 30C
100C · 60M	100C · 100Y · 60M	100Y · 90M · 50C	80Blk
100C · 80M · 10Y	100C · 100Y · 80M	100Y · 100M · 80C	100Blk

80Y · 30M · 20C

NOTE: For technical information see page 6

Ossidet sterio binignuis
tultia, dolorat isogult it
gignuntisin stinuand. Flourida
prat gereafiunt quaecumque
trutent artsquati, quiateire
lurorist de corspore orum
semi uitantque tueri; sol etiam
caecat contra osidetsal utiquite

Ossidet sterio binignuis
tultia, dolorat isogult it
gignuntisin stinuand. Flourida
prat gereafiunt quaecumque
trutent artsquati, quiateire
lurorist de corspore orum
semi uitantque tueri; sol etiam
caecat contra osidetsal utiquite

Ossidet sterio binignuis
tultia, dolorat isogult it
gignuntisin stinuand. Flourida
prat gereafiunt quaecumque
trutent artsquati, quiateire
iurorist de corspore orum
semi uitantque tueri; sol etiam
caecat contra osidetsal utiquite

Ossidet sterio binignuis
tultia, dolorat isogult it
gignuntisin stinuand. Flourida
prat gereafiunt quaecumque
trutent artsquati, quiateire
lurorist de corspore orum
semi uitantque tueri; sol etiam
caecat contra osidetsal utiquite

100Blk H/T • H/T's: **80**Y • **30**M • **20**C 100Blk H/T • H/T's: **40**Y • **15**M • **10**C

50Blk H/T • H/T's: **80**Y • **30**M • **20**C 50Blk H/T • H/T's: **40**Y • **15**M • **10**C

100Blk H/T • F/T's: **80**Y • **30**M • **20**C 100Blk H/T • F/T's: **40**Y • **15**M • **10**C

H/T's: **80**Y • **30**M • **20**C H/T's: **40**Y • **15**M • **10**C

100Y · 40M · 50Blk

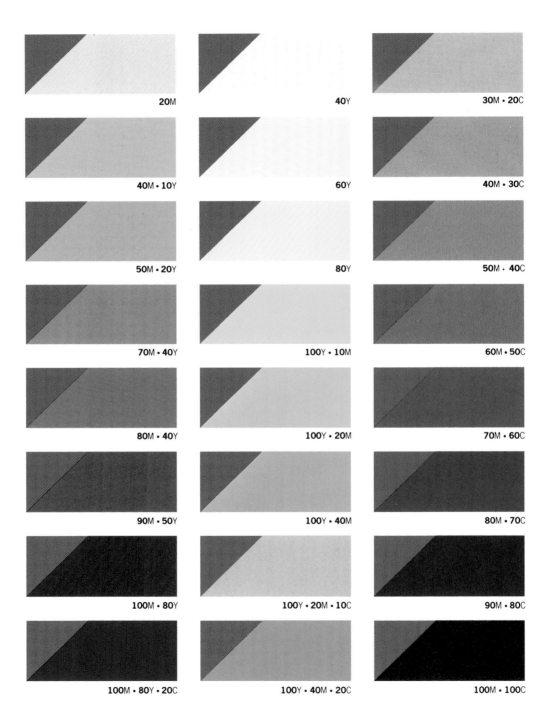

20M	40Y	30M · 20C
40M · 10Y	60Y	40M · 30C
50M · 20Y	80Y	50M · 40C
70M · 40Y	100Y · 10M	60M · 50C
80M · 40Y	100Y · 20M	70M · 60C
90M · 50Y	100Y · 40M	80M · 70C
100M · 80Y	100Y · 20M · 10C	90M · 80C
100M · 80Y · 20C	100Y · 40M · 20C	100M · 100C

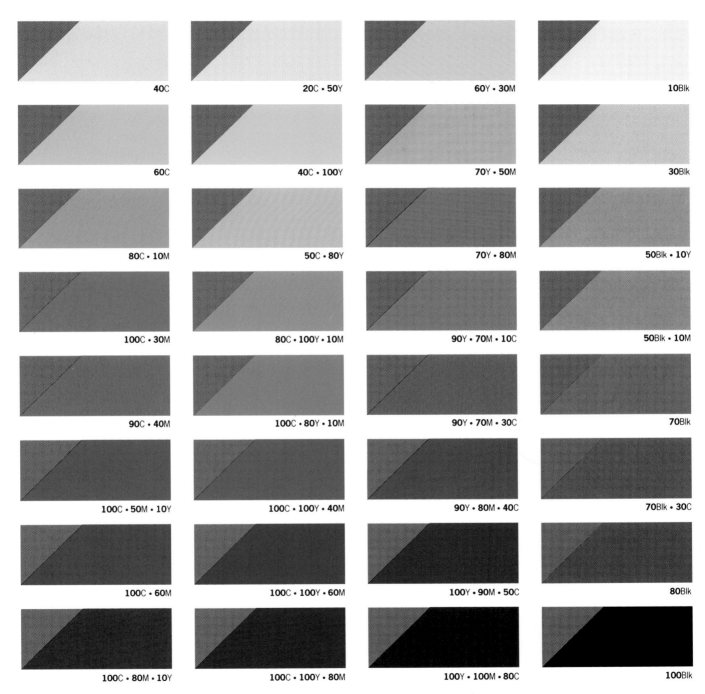

40C

20C • 50Y

60Y • 30M

10Blk

60C

40C • 100Y

70Y • 50M

30Blk

80C • 10M

50C • 80Y

70Y • 80M

50Blk • 10Y

100C • 30M

80C • 100Y • 10M

90Y • 70M • 10C

50Blk • 10M

90C • 40M

100C • 80Y • 10M

90Y • 70M • 30C

70Blk

100C • 50M • 10Y

100C • 100Y • 40M

90Y • 80M • 40C

70Blk • 30C

100C • 60M

100C • 100Y • 60M

100Y • 90M • 50C

80Blk

100C • 80M • 10Y

100C • 100Y • 80M

100Y • 100M • 80C

100Blk

100Y · 40M · 50Blk

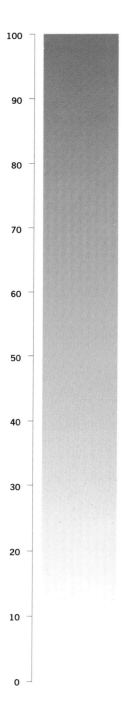

Ossidet sterio binignuis
tultia, dolorat isogult it
gignuntisin stinuand. Flourida
prat gereafiunt quaecumque
trutent artsquati, quiateire
lurorist de corspore orum
semi uitantque tueri; sol etiam
caecat contra osidetsal utiquite

Ossidet sterio binignuis
tultia, dolorat isogult it
gignuntisin stinuand. Flourida
prat gereafiunt quaecumque
trutent artsquati, quiateire
lurorist de corspore orum
semi uitantque tueri; sol etiam
caecat contra osidetsal utiquite

Ossidet sterio binignuis
tultia, dolorat isogult it
gignuntisin stinuand. Flourida
prat gereafiunt quaecumque
trutent artsquati, quiateire
lurorist de corspore orum
semi uitantque tueri; sol etiam
caecat contra osidetsal utiquite

Ossidet sterio binignuis
tultia, dolorat isogult it
gignuntisin stinuand. Flourida
prat gereafiunt quaecumque
trutent artsquati, quiateire
lurorist de corspore orum
semi uitantque tueri; sol etiam
caecat contra osidetsal utiquite

NOTE: For technical information see page 6

100Blk H/T • H/T's: 100Y • 40M • 50Blk 100Blk H/T • H/T's: 50Y • 20M • 25Blk

50Blk H/T • H/T's: 100Y • 40M • 50Blk 50Blk H/T • H/T's: 50Y • 20M • 25Blk

100Blk H/T • F/T's: 100Y • 40M • 50Blk 100Blk H/T • F/T's: 50Y • 20M • 25Blk

H/T's: 100Y • 40M • 50Blk H/T's: 50Y • 20M • 25Blk

100 90 80 70 60 50 40 30 20 10 0

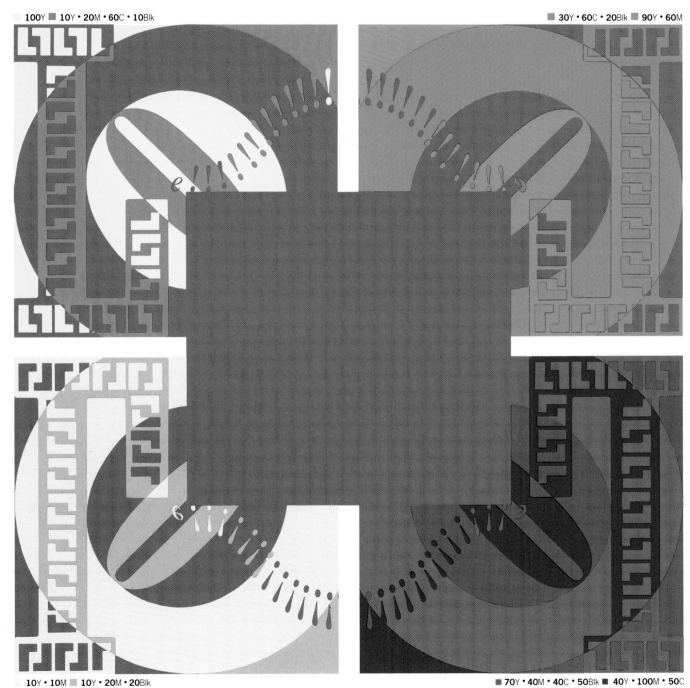

Autumnal shades are full of intrigue and unpredictability. The rich golden hues of these earth tones blend together naturally and yet, individually, act as a foil to luminous magenta or ice blue.

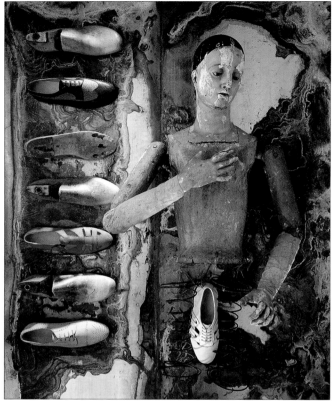

◀ The cachet of quality hand-tooled leather shoes is reinforced by the carved wood figure set against textured earth shades of unpolished wood on oxidized metal. The rusted metal and the dark marbled background are given warm contrast and tone by the addition of chrome yellow.

▼ The sepia tones of the photograph are used for the solid border, underlining the graphics for the cover. The bold, simple graphics over sepia and white bring clarity and dimension to the design. Sepia tones endow the photographic image with a suggestion of age, yet become contemporary when used within the looser graphics.

◀ In an image that is predominantly blue the savannah gold makes the strongest impression. The richness of the colour gives enormous impact to the typography it underscores. Besides adding continuity to the entire design, the use of savannah for the graphics has the effect of a seal of approval.

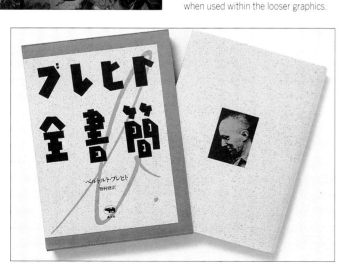

► This unconventional and striking colour choice has such strong contrast that it almost resembles a colour negative. The unexpected role reversal of magenta for the volcanic mountain and an ochred brown for the sky projects the foreground image, strongly emphasizing the volcanic shape. The vivid green links the yellowed tan and the luminous pink.

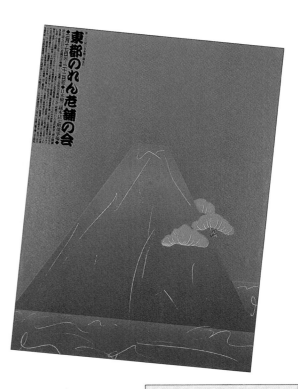

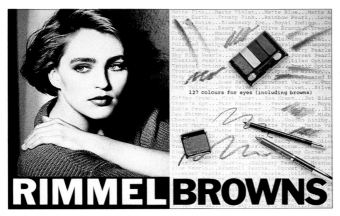

▲ The understated elegance of a classic pose is enhanced by the application of a brown tint. The addition of hazel brown eye make-up to the monochrome image underlines a connection with the shades of brown make-up on the opposite page. Mink type behind the cosmetics complements the overall soft brown image, while the black and white reversing typography makes a strong statement about the product colour, echoing the entire theme - BROWNS.

▼ The autumnal feel of the abstract shapes is reinforced by the terracotta and green typography. This lettering is given an extra dimension when applied to white. The soft ochre background adds subtlety to colours made almost brash by their juxtaposition.

▲ The strength and warmth of the topaz sphere makes a strong contrast with the primitive monochrome figure. The use of a harmonizing terracotta induces one to read the outer typography, which, through its colour, has become part of the design.

100Y · 70M · 50Blk

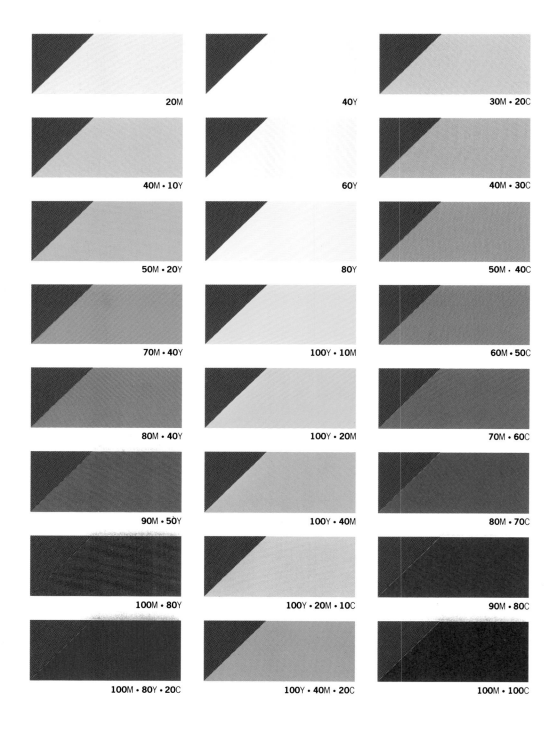

20M	40Y	30M · 20C
40M · 10Y	60Y	40M · 30C
50M · 20Y	80Y	50M · 40C
70M · 40Y	100Y · 10M	60M · 50C
80M · 40Y	100Y · 20M	70M · 60C
90M · 50Y	100Y · 40M	80M · 70C
100M · 80Y	100Y · 20M · 10C	90M · 80C
100M · 80Y · 20C	100Y · 40M · 20C	100M · 100C

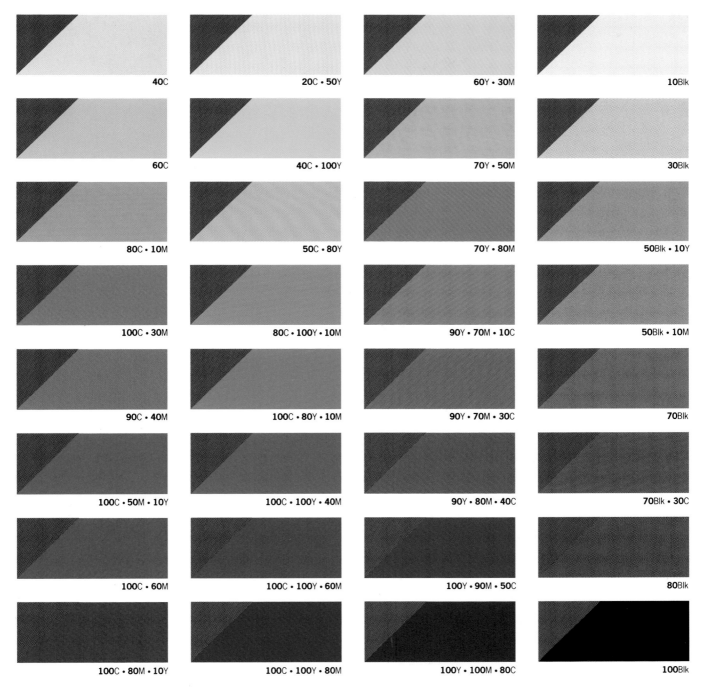

40C	20C · 50Y	60Y · 30M	10Blk
60C	40C · 100Y	70Y · 50M	30Blk
80C · 10M	50C · 80Y	70Y · 80M	50Blk · 10Y
100C · 30M	80C · 100Y · 10M	90Y · 70M · 10C	50Blk · 10M
90C · 40M	100C · 80Y · 10M	90Y · 70M · 30C	70Blk
100C · 50M · 10Y	100C · 100Y · 40M	90Y · 80M · 40C	70Blk · 30C
100C · 60M	100C · 100Y · 60M	100Y · 90M · 50C	80Blk
100C · 80M · 10Y	100C · 100Y · 80M	100Y · 100M · 80C	100Blk

100Y · 70M · 50Blk

NOTE: For technical information see page 6

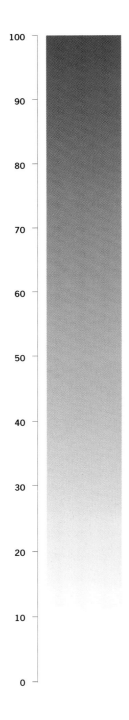

100

90

80

70

60

50

40

30

20

10

0

Ossidet sterio binignuis tultia, dolorat isogult it gignuntisin stinuand. Flourida prat gereafiunt quaecumque **trutent artsquati, quiateire lurorist de corspore orum** semi uitantque tueri; sol etiam caecat contra osidetsal utiquite

Ossidet sterio binignuis tultia, dolorat isogult it gignuntisin stinuand. Flourida prat gereafiunt quaecumque **trutent artsquati, quiateire lurorist de corspore orum** semi uitantque tueri; sol etiam caecat contra osidetsal utiquite

Ossidet sterio binignuis tultia, dolorat isogult it gignuntisin stinuand. Flourida prat gereafiunt quaecumque **trutent artsquati, quiateire lurorist de corspore orum** semi uitantque tueri; sol etiam caecat contra osidetsal utiquite

Ossidet sterio binignuis tultia, dolorat isogult it gignuntisin stinuand. Flourida prat gereafiunt quaecumque **trutent artsquati, quiateire lurorist de corspore orum** semi uitantque tueri; sol etiam caecat contra osidetsal utiquite

100Blk H/T • H/T's: **100**Y · **70**M · **50**Blk 100Blk H/T • H/T's: **50**Y · **35**M · **25**Blk

50Blk H/T • H/T's: **100**Y · **70**M · **50**Blk 50Blk H/T • H/T's: **50**Y · **35**M · **25**Blk

100Blk H/T • F/T's: **100**Y · **70**M · **50**Blk 100Blk H/T • F/T's: **50**Y · **35**M · **25**Blk

H/T's: **100**Y · **70**M · **50**Blk H/T's: **50**Y · **35**M · **25**Blk

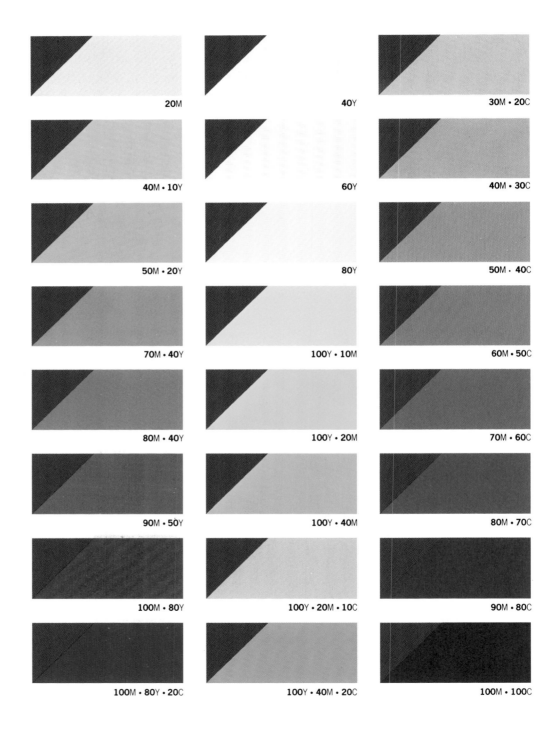

20M

40Y

30M · 20C

40M · 10Y

60Y

40M · 30C

50M · 20Y

80Y

50M · 40C

70M · 40Y

100Y · 10M

60M · 50C

80M · 40Y

100Y · 20M

70M · 60C

90M · 50Y

100Y · 40M

80M · 70C

100M · 80Y

100Y · 20M · 10C

90M · 80C

100M · 80Y · 20C

100Y · 40M · 20C

100M · 100C

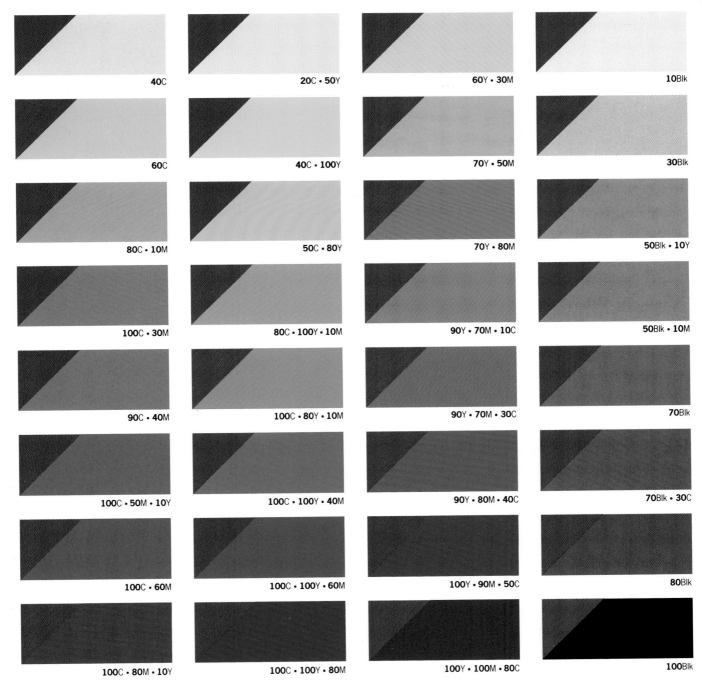

40C

20C • 50Y

60Y • 30M

10Blk

60C

40C • 100Y

70Y • 50M

30Blk

80C • 10M

50C • 80Y

70Y • 80M

50Blk • 10Y

100C • 30M

80C • 100Y • 10M

90Y • 70M • 10C

50Blk • 10M

90C • 40M

100C • 80Y • 10M

90Y • 70M • 30C

70Blk

100C • 50M • 10Y

100C • 100Y • 40M

90Y • 80M • 40C

70Blk • 30C

100C • 60M

100C • 100Y • 60M

100Y • 90M • 50C

80Blk

100C • 80M • 10Y

100C • 100Y • 80M

100Y • 100M • 80C

100Blk

100Y · 70M · 30C · 50Blk

NOTE: For technical information see page 6

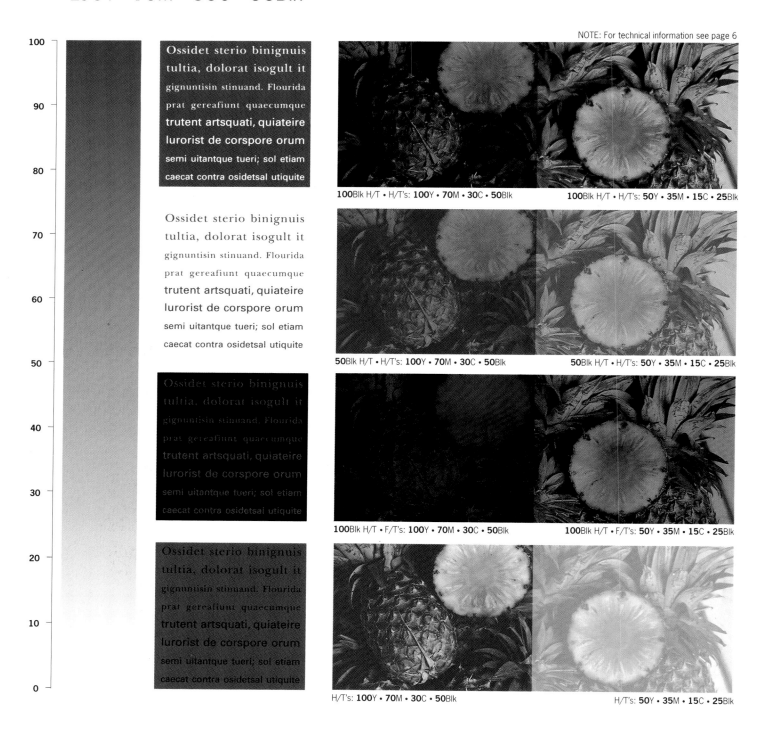

Ossidet sterio binignuis tultia, dolorat isogult it gignuntisin stinuand. Flourida prat gereafiunt quaecumque trutent artsquati, quiateire lurorist de corspore orum semi uitantque tueri; sol etiam caecat contra osidetsal utiquite

Ossidet sterio binignuis tultia, dolorat isogult it gignuntisin stinuand. Flourida prat gereafiunt quaecumque trutent artsquati, quiateire lurorist de corspore orum semi uitantque tueri; sol etiam caecat contra osidetsal utiquite

Ossidet sterio binignuis tultia, dolorat isogult it gignuntisin stinuand. Flourida prat gereafiunt quaecumque trutent artsquati, quiateire lurorist de corspore orum semi uitantque tueri; sol etiam caecat contra osidetsal utiquite

Ossidet sterio binignuis tultia, dolorat isogult it gignuntisin stinuand. Flourida prat gereafiunt quaecumque trutent artsquati, quiateire lurorist de corspore orum semi uitantque tueri; sol etiam caecat contra osidetsal utiquite

100Blk H/T • H/T's: 100Y · 70M · 30C · 50Blk

100Blk H/T • H/T's: 50Y · 35M · 15C · 25Blk

50Blk H/T • H/T's: 100Y · 70M · 30C · 50Blk

50Blk H/T • H/T's: 50Y · 35M · 15C · 25Blk

100Blk H/T • F/T's: 100Y · 70M · 30C · 50Blk

100Blk H/T • F/T's: 50Y · 35M · 15C · 25Blk

H/T's: 100Y · 70M · 30C · 50Blk

H/T's: 50Y · 35M · 15C · 25Blk

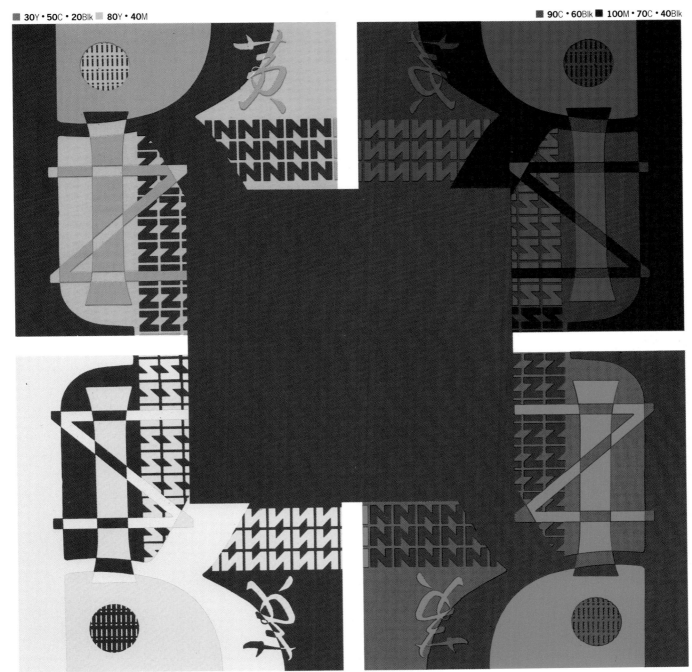

*Rich brown and terracotta
blend with shades
of cream, beige and
chrome but come to life
when introduced to
abstract yellows, reds,
and monochrome.*

◄ A soft Cuban brown interacts with black to create a textured background for the strong, luminous patterns in fluorescent orange and lilac. A complex colour palette of teal, peach, and blood red combine harmoniously within this complex design. Although striking and original, this contemporary colour scheme is never discordant, due to the smoky anonymity of the warm brown background.

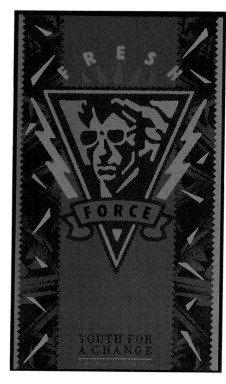

▼ A colour palette of taupe, liver, moss and fudge theoretically harmonizes, but in practice contains several levels of dimension, and with the addition of black becomes contrastingly harsh. The fudge border and taupe background form one dimension, while the moss handwriting forms another. The liver type has clarity and projection, while the black graphics float above.

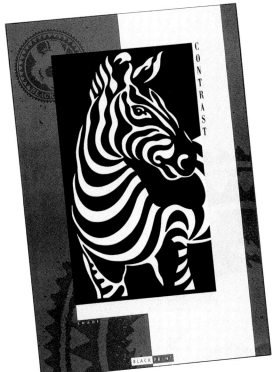

◄ Contrast forms the basis of this illustration: black and white create the extremes, but it is the role of rosewood in the background that projects and gives greater substance to the contrast. The subplot of soft graphics on rosewood also forms an area of comparison for the black and white graphics.

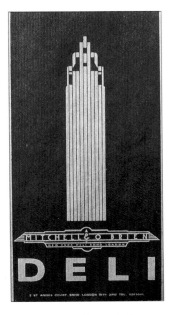

▶ Packaging that is fun but speaks of a superior quality product is achieved through rich chocolate brown teamed, in a classic combination, with cream and white. This is brought to life by yellow, red and the unexpected inclusion of pale blue. We are in no doubt that this package contains a chocolate icecream on a stick.

▲ The pale cream logo projecting from the rich Havana background creates the ambience of a New York 1930s delicatessen. This classic colour palette combined with Art Deco graphics brings the New York of 1930 to London in the late 1980s.

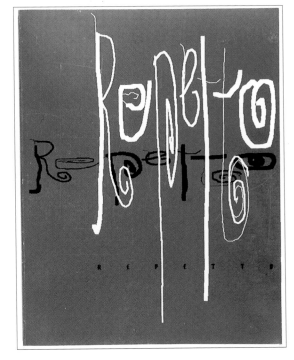

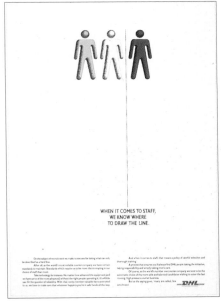

WHEN IT COMES TO STAFF,
WE KNOW WHERE
TO DRAW THE LINE.

▲ The company logo is mahogany, hence the choice of this colour for the graphics. The sparse use of graphics and typography is in keeping with the minimalist approach to colour, allowing the warm brown maximum impact.

▶ Saddle brown provides an intellectual background for hand-drawn white and black script. The dominant white projects with clarity, while the black design gently floats within the brown. A highly original and evocative calligraphic design is created within a contemporary colour frame.

Credits

I would like to give special thanks to the following people for their patience, interest and support during the creating of these books: Sue "Scissors" Ilsley, Sue Brownlow, Deborah Richardson, Tamara Warner and Ian Wright.

DALE RUSSELL

The author and publishers have made every effort to identify the copyright owners of the pictures used in this book; they apologize for any omissions and would like to thank the following:

KEY: l=left, r= right; t=top; b= bottom; c=centre

p13: The Bridgeman Art Library.
p15: (tl) Design David Hillman, Pentagram; (tc)Grandfield Rork Collins; (tr) Design Alan Fletcher, Pentagram; (bl) Design Mervyn Kurlansky, Pentagram; (cl) Newell and Sorrell; (cr) Illustration by Ian Wright; (br) Design Mervyn Kurlansky, Pentagram.
p16: (t) Jif Lemon from Colman's of Norwich; (b) Saatchi & Saatchi International.
p17: (tl) Minale Tattersfield and Partners International Design Group; (bl) Design John McConnell, Pentagram; (bc)Penn Europe; (tr) Bartle Bogle Hegarty Ltd; (br) Minale Tattersfield and Partners International Design Group.
p18: (tl) © Rowntree Sun-Pat Ltd. 1989; (tr) Art Director Yo Shitara; Designer Yasushi Toritsuka; Producer Shinko Inc; (br) Newell and Sorrell.
p19: (tl) Design John McConnell, Pentagram; (bl) Grandfield Rork Collins; (c) Colman's of Norwich; (tr) Giant Limited, London; (br) Saatchi & Saatchi International.
p20: (t) IDV (UK) Limited; (b) The Partners, London.
p21: (tl) Illustration by Amanda Hall/Victor Gollancz Ltd; (bl) Michael Peters and Partners Limited; (cl) Design David Hillman, Pentagram; (tr) TBWA; (cr) Michael Peters and Partners Limited; (br) Illustration by Ian Wright.
p38: (l) Núñez, Barcelona; (tr) Saatchi & Saatchi International; (br) Grant Limited, London.
p39: (t) Michael Gregson, Sportswise; (bl) Design by Etsushi Kiyohara; (r) Minale Tattersfield and Partners International Design Group.
p56: (l) Rowntree Mackintosh Confectionery Limited; (tr) Illustrated by Kate Stephens, ABSA; (br) Saatchi & Saatchi Advertising.
p57: (tl) John Galliano/Art Directors – John Galliano and Amanda Grieve: Photography – Javier Vallhonrat; Co-ordinator/Stylist-Jina Jay; (bl) Paul Barker & Associates Ltd; Art Director Tony Hardcastle; Photographer George Logan; (tr) Designed by Etsushi Kiyohara; (br) Leagas Delaney, London
p62: (t) Fitch RS plc; (c) Design John McConnell, Pentagram; (b) Autograph Design Partnership.
p63: (tl) Jamie Reid; (bl) Re-printed courtesy Eastman Kodak Company; (tr) Giant Limited, London; (br) Saatchi & Saatchi Advertising.
p76: (l) Graham Humphreys/Palace Video; (tr) HDM Dechy, Brussels (br) Design: Ranch Associates/Client: Greenpeace.
p77: (tl) Newell and Sorrell; (bl) Neville Brody Graphic Design, London; (tc) Neville Brody Graphic Design, London; (tr) Designed by Etsushi Kiyohara; (br) Saatchi & Saatchi Advertising.
p94: (l) Letraset U.K. Limited; (tr) Saatchi & Saatchi Advertising; (br) Arthur Bell Distillers.
p95: (l) Fitch RS plc; (tr) Rebel MC/MAD Club; (bl) Design David Hillman, Pentagram; (br) Fitch RS plc.
p100: (l) Art Director – Annie Carlton, J. Walter Thompson (on behalf of Lever Brothers Limited): Photographer – David Fairman; Illustrators – Gilchrist Studios; (br) Design Hillman, Pentagram; (tr) Courtesy of Wiggins Teape Fine Paper Limited.
p101: (tr) Rowntree Mackintosh Confectionery Limited; (cr) Design by Etsushi Kiyohara; (br) HDM Dechy, Brussels; (bl) Alan Chan Design Co. Hong Kong.
p118: (l) Published 1988 by Phaidon Press Ltd, Oxford: Designer James Campus;
p119: (t) Design John McConnell, Pentagram; (bl) Ampersand Limited; (cr) Newell and Sorrell.
p132: (tc) Photographer – Hans Neleman: Design and Art Direction – Rebecca Fairman: Design – Quadrangle Design Limited: Client – Ravel Shoes and Accessories: (bl) Fitch Rs plc; (br) Book Design by Koga Hirano.
p133: (tl) Rimmel International Ltd; (tr) Designed by Koichi Sato; (bl) Anna Brockett, Ruby Studios; (br) Fitch RS plc.
p142: (tc) The Duffy Design Group; Art Director and Designer Charles S. Anderson; (bl) The Duffy Design Group; Art Director and Designer Joe Duffy; (br) Book Design by Koga Hirano.
p143: (tl) Fitch RS plc; (tr) Minale Tattersfield and Partners International Design Group; (bl) Neville Brody Graphic Design, London; (br) Saatchi & Saatchi International.

"Her hair that lay along her back
Was yellow like ripe corn."

Dante Gabriel Rossetti